rediscover yourself
REDEFINE YOUR LIFE

A GUIDE TO CREATING CONFIDENCE & FINDING FULFILLMENT.

REBECCA CORVIN

Rediscover Yourself, Redefine Your Life: A Guide to Creating Confidence & Finding Fulfillment

Copyright © 2024 Rebecca Corvin

No part of this book may be reproduced or transmitted in any form or by any means, electronic or mechanical, including photocopying and recording, or by any information storage or retrieval system, except as may be expressly permitted by the 1976 Copyright Act or in writing from the publisher. Requests for permission should be addressed to storybuilderspress@gmail.com

Published by Storybuilders Press

Paperback: 978-1-954521-48-3
Audio: 978-1-954521-45-2
eBook: 978-1-954521-47-6

To Arlyn and Eva, for whom I have always been enough.

CONTENTS

Author's Note ... 1

PART I: THE BATHTUB ... 5
 1. Without Wax ... 11
 2. The Space Between .. 21
 3. The Liminal Advantage 31
 4. The PACT .. 41

PART II: THE FIVE FACETS OF FULFILLMENT 53
 5. The First Facet: Schedule 59
 6. The Second Facet: Significance 67
 7. The Third Facet: Satisfaction 81
 8. The Fourth Facet: Senses 115
 9. The Fifth Facet: Spirituality 127

PART III: TIME TO TAKE ACTION 139
 10. The Five Steps to Fulfillment 147
 11. Tried-And-True Tools 171
 12. Redefine Your Life 195

Acknowledgments ... 221
Endnotes ... 227
About the Author ... 229

REDISCOVER

to discover (something forgotten or ignored) again

REDEFINE

to define (something, such as a concept) again

AUTHOR'S NOTE

I'm so glad you're here and have committed to yourself by choosing this book (or maybe *it* chose *you*). In the upcoming pages, you're going to be introduced to tools and information, practical and applicable things you can apply to your life almost immediately.

It is important to me that what you obtain in this book is valuable, that the parts of my story I share with you are meaningful and relatable, and that you soon realize I am not nearly as serious (most of the time) as I may look on the cover of this book.

The work you are about to do is powerful. It's challenging, but it's worth it. Nobody can change your life other than you. Nobody has the calling you do. Nobody has the past you do or the future you do. And as you realize this, you'll develop a confidence you have never had before.

I'd like to ask you to withhold your impulse to take quick action, and instead, take your time turning these pages. Read slowly. Pray fervently. Savor the moments of reflection you'll have on all of the beautiful and unique versions of yourself. After all, it has most likely taken many years of change, pain, heartbreak, learning, growth, and adjustment from those versions of you to get you here now. And those parts of you should be seen and honored.

It is possible you're feeling unsure of where you are in your life. You're going through the motions, but you don't really feel alive. You're looking around at the material things you've accumulated, the worldly successes you've achieved, but you feel empty.

You're not alone.

My hope is that the message in this book impresses upon you. That it doesn't just reach your mind, but it makes its way into your heart, helping it to soften, to love, and to accept. My goal is to show you that while what you're feeling now is real, it is also only a byproduct of a limited scope.

The information in this book will help you begin to understand that while it can feel like you're lost, you are actually perfectly positioned for your next move. And while your current circumstances may have you second-guessing your ability, you are already equipped to live a life where you can actually trust yourself and take your next steps assuredly.

These tools will teach you how to create confidence, find real fulfillment, and balance all of the most important things in life while still enjoying them.

To do so, we'll be brushing the dust off the parts of you that have been dormant for some time. We'll be carving away the layers of others' opinions and projections. We will celebrate and honor the past versions of you that no longer serve you. We will mourn and bury the life you once thought you were going to have, with people you once thought were never going to hurt or leave you.

You're going to find a new, firm foundation. You're going to crawl and then find your footing. You're going to observe, be thoughtful, and give yourself the space and time you need to rediscover yourself, one step at a time.

There are no right or wrong answers. There are no hard and fast rules. This book is a proxy for you to insert all of your own stories, your own truths, your own experiences. It is a portal for you to become actually who you are potentially. This is a guidebook that will help you to curate a life that is designed for you, by you. Grab a coffee. Grab your journal. Get comfortable. Let's go.

PART I

THE BATHTUB

I could barely see anything. I was getting goosebumps, and my fingers were like prunes. I dozed off. *What time is it anyway?* All I knew was when I got into the tub it was daylight, and now it wasn't.

I turned on the faucet in an attempt to warm up a bit. The bath water I was sitting in was finally giving up on me, and so was my hot water tank.

It was in this place where I spent hours and hours reflecting on the past ten years. My mind raced. Time collapsed.

I had finished college, started working, established a business, then two, then three. I got married, became a mother to my son, and then again to my daughter. I battled postpartum anxiety and depression as a high-functioning friend, wife, business owner, and employee.

It was in this place I was able to, with hindsight, connect dots I would never have been aware of in the moment. It was where God's grace was revealed to me repeatedly in situations I would have never made it out of on my own.

It was where I realized that although there had been struggle, I really had accomplished so much. Every box society drew up for me to check had been checked off before I even turned thirty.

And all for what? To end up *here*? Sitting in a cold bathtub, staring at the divorce papers I picked up from the post office last week?

My focus came back to the cold bath. I debated freezing to death, but I quickly realized taking that route would prevent me from experiencing the one thing I was able to look forward to in life these days: coffee.

So, in an effort to force myself to actually do something, I leaned over the side of the tub, grabbed the towel I had reused for the past several days, and climbed out. I looked at myself in the mirror and started to cry.

> "She weeps bitterly during the night, with tears on her cheeks. There is no one to offer her comfort, not one from all her lovers. All her friends have betrayed her; they have become her enemies." —Lamentations 1:2

It had been several weeks since my husband left, along with all of his things. It had been days since I had seen my children. And, thanks to COVID lockdown orders, it felt like it had been a year since I had been anywhere other than this house.

I was driving myself insane. Or, maybe, my insanity was the very thing that drove me here. At this point, should I even care? Was I capable of caring?

My body was numb from the cold water. My brain was numb from constant overanalysis of my current situation. My heart was numb from the loneliness and the distance from my children.

The only things I felt even close to capable of doing were rinsing and refilling my bathtub and rinsing and refilling the coffee pot.

I took a deep breath and didn't even bother to wipe the tears from my face. It would take too much energy, and I needed that energy to brew my coffee.

I made it into the kitchen and began the ritual of grinding the beans, lining the tray with a filter, sliding it into its place in the coffee pot, and adding water. While it brewed, I poured my favorite milk into the frother I had purchased for myself while I was manic in my online shopping. I watched the coffee drip into the pot, milk swirling in the frother, and felt a small sense of satisfaction.

I poured the coffee into my favorite mug (they are all my favorite mugs!) and walked across the terra-cotta tile in the living room to the chaise lounge in the corner by the floor-to-ceiling windows. With my towel still wrapped around me and tears still drying on my face, I closed my eyes, took a sip of my coffee, and smiled.

It was in *this* place I talked to God—this place of gratitude for the small and delicate things that allowed my mind and body to drift away from the chaos in the world and in my life.

Some days I would talk. Others I would listen. Most days, there was a back-and-forth conversation that lasted longer than the conversations with my best friends.

> "All things work together for good to those who love God, to those who are called according to His purpose." —Romans 8:28

As I drank my coffee and looked out the windows, I anchored into the knowing that "all things work together for good to those who love God, to those who are called

according to *His* purpose" (Romans 8:28). I knew this to be true in my bones.

So why, then, did I find myself depressed and alone, trying to make sense of the clamor that had taken over not only my life but also the world, so abruptly?

CHAPTER ONE

WITHOUT WAX

I imagined myself as a statue that had taken years and years to perfect—one of the statues you'd see on a pedestal in a big room of a museum with a white marble floor. Only instead of standing confidently, with power and strength, I felt as if a nefarious being broke into the museum insidiously and used all of its force to knock me down and shatter me into pieces.

I felt attacked. Stolen from. Broken. Like pieces of me were lying raw and exposed on the cold floor under the bright lights of interrogation.

There were whispers from those watching, but instead of running in to help reassemble me, the people who witnessed the fall chose to tiptoe around the broken pieces with a "She'll figure it out; she always does" demeanor paired with a "We aren't going to talk about this" mentality.

> **"Is this nothing to you, all you who pass by? Look and see! Is there any pain like mine, which was dealt out to me, which the Lord made me suffer on the day of his burning anger?" —Lamentations 1:12**

Was I willing to pick up the pieces? Were some of them even worth picking up or should they be left behind? Clearly, no one else was going to do it for me. At thirty years old, I'd been waiting for someone to piece me back together for my entire life. Why even take the time to clean up this mess when I'd never be the same again?

This statue would never be as beautiful or complete. Instead, it would be corrupted with fractures and missing chunks. As I contemplated the effort it would take to restore myself, I remembered something one of my early mentors shared with me.

One of his daughters was getting ready to attend college, and he told her that he was so proud of her for getting into the program that she did and for her accomplishments up to this point in life. He told her that he loved her so much, *without wax.*

After pausing for dramatic effect, he revealed that sculptors, when creating a piece, would use wax to fill in holes or remedy imperfections while they were working. So, what he was trying to convey to his daughter, who originally did not understand what he was trying to say either, was that regardless of anything she may perceive in herself as an insecurity or flaw, he would always love her, as is, *without the wax.*

I took another sip of my coffee and stared out into the distance. Could I love myself the way he loved his daughter? Could I find a part of me willing to believe that I was exactly where I needed to be for a purpose that I may not have had visibility of yet? Could I wrap my head around the idea that maybe I was *supposed* to experience

this pain? That maybe I am meant to be reassembled, in *an even better way* than before?

I took a deep breath and negotiated with myself. Even if I couldn't be entirely invested in those ideas, the majority of my being was willing. I would later realize that the willingness to acknowledge and accept this as my truth, in this moment, would be the advantage that would carry me through the next few years.

But for now, I had to remind myself that although God promises us a lot of things, He doesn't ever promise us that it will be easy. In fact, I was acutely aware of the joy, peace, love, faithfulness, and kindness that often swept through my life, and I felt like I was a regular at being grateful for all of it.

This, though. Sitting with my hair still wet, wrapped in a towel, finishing my coffee in a house so quiet it was deafening.

> "But the fruit of the Spirit is love, joy, peace, longsuffering, kindness, goodness, faithfulness, gentleness, self-control." —Galatians 5:22

This wasn't any of that. This wasn't one of the fruits of the Spirit that was easy to get excited about. This was long-suffering. This was self-control. This was gentleness.

This was the moment that I knew I was being called for something greater. It was the fork in my road.

I could turn left down the path I had traveled many times before. The path of self-pity, victimhood, and shame. A path where I was the problem, and there was no solution. An infinity of becoming, doing, and trying—only to realize I'd never be enough.

Or, I could do something that I had never really done before. I could step out to the right. I could step out of the boat and *onto* the water. I could really, actually trust that I was prepared for this moment. That something magical was going to sprout from the pain. That everything up to this moment was happening for me (not *to* me), giving me an edge over the situation that would lead me to exactly where I needed to be.

I closed my eyes again and took another deep breath. I was willing and I was ready to leave the redundancy of insanity behind and make a pact with myself and with God to pursue something new, to pursue not who the world had been coercing me to be—which consistently ended in disconnect and unfulfillment—but to persistently and relentlessly pursue the person God intended me to be, to commit to reassembling myself, without wax.

REBIRTH IN THE BACK ROW

A few days later, I was starting to panic about this "relentless pursuit" and "pact with God" thing. It sounded good, you know, in theory—when I was amped up on my foamy coffee and the dopamine hit from hours of soaking in Epsom salts.

But now, here I was. Dressed. With brushed hair and mascara. Holding a Bible with my head bowed and legs crossed in the back row of a small church I was led to as a new member of the congregation. Nervous. And second-guessing it all.

I figured if I was going to enter into agreements with God, the least I could do was visit His house. It's not like I had anything better to do. Plus, God was tugging on my heart to go, so I did.

I guess I thought I'd walk in and all of my worries would be "washed away." Isn't that what all of the aesthetic social media posts claim? Isn't church the place we are supposed to go for shelter from the storm? Isn't God supposed to provide relief and alleviate the trials we face in life?

I shifted my weight and recrossed my legs. I tried to take a deep breath, to really let myself be present. But I couldn't.

This was ridiculous. What was I doing? Showing up in a church when my life had bottomed out—how cliché.

I was lost and disoriented. It was as if my days had turned upside down. I had an overabundance of free time, but it was consumed by ruminating thoughts and tireless spirals of wonder. *What was I going to do? What was next? How would I ever bounce back from this?*

I started collecting my things and decided I'd bolt as soon as I could do it without drawing attention. I couldn't handle human interaction right now, and I was infuriated with myself for even showing up.

I wasn't feeling relief. I barely even paid attention to the sermon. I felt like everyone was staring at me and suddenly knew about my situation and my problems. I was frantic about this hefty agreement I made with God. I wanted to give up.

Relentlessly pursue myself?
Seriously?

My attention turned back to the service when I heard the piano. The pastor concluded his message, and his wife, the pianist, played some closing music as we were given time to pray silently.

When I heard the music, my nerves calmed. My heart softened. I stopped fidgeting and sat still. I felt embraced by the melody, like I had been given permission to melt, to feel, to release.

My earlier attempt to flee was replaced with curiosity. Instead of considering all of the reasons for leaving, my thoughts condensed into a new question: *What would happen if I stayed?*

After all, I had been trying it "my way" for ... well, forever. My way consisted of minimal collaboration (a.k.a. shutting people out) and was contingent on *me* being the leader, the spearhead, the one with all of the answers (a.k.a. in control).

From a young age, the feeling of strength and responsibility had been instilled within me, sometimes to a fault. I had grown to be hyper-independent in just about every aspect of my life thanks to the strong women in my family and those I had been exposed to growing up. I heard stories about how hard they had worked, what they had gone through.

I watched my mother work night shifts and manage money carefully. I understood early how it made her feel to juggle so much. My sister and I would go with her to work when we were young. I later worked with her, at my first job as a waitress, until she decided to become a real estate agent and redefine her own life.

Watching my mom work relentlessly in pursuit of the life she wanted inspired me. Knowing that my work ethic came from my parents, and their parents, and their parents made me realize it would be, at a minimum, disrespectful to them (let alone my children) if I simply settled now.

Up to this point, I had exceptionally high bare minimum requirements for everyone around me, making my ability to be satisfied exceptionally low. If it wasn't done my way, or close to it, then in my eyes, it wasn't done. And not only was it not done, but it also caused me extra work. Because I had to do it again—or clean up after it—and the whole process would've been more streamlined if I would have just taken care of it from the start.

This time, though, even though I knew I *could*, I didn't *want* to take care of it. I didn't have the energy, let alone the answers. This problem was big. Bigger than me.

My human mind literally could not fathom the answers to what was next or how I was going to bounce back from this.

My emotions were telling me it was all over. Life itself had become too difficult. There would never be another thing I could do to be happy. I had better get used to the bathtub, the coffee pot, the loneliness.

I had no job. No foreseeable steady income.

I felt like I had no support. No help.

I was outnumbered and anxious when I had my two young children with me, and when I didn't, I was crying on the floor in their bedrooms.

Now, I found myself crying in the back row of this small-town Bible Baptist Church, negotiating with God, and coming to terms with my new reality.

My marriage was over. No more husband meant I was no longer a wife. The four-bedroom, two-bathroom house we fought over purchasing together was on the market, and there was a stack of canvas photos of our former family in the attached two-car garage. The children I'd slept with every single night since the day they were born were now only mine half the time, and exchanging them took place in the parking lot of a gas station in silence.

I cringed. The music ended. I didn't want to move.

The pianist walked up to me and introduced herself. We shared some small talk, a hug, and some conversation about our children. She was kind and genuine. I knew I needed a friend like her. And apparently, so did God.

Her generosity and hospitality were something foreign to me and hard to receive. I hadn't realized how deprived I had been of genuine love and connection until it was right in front of me. My ability to experience it up to this point had been offset by my survival mode instincts to make it through the waves of depression, anxiety, and hurt that plagued me most of my life.

I couldn't remember the last time I felt such a sense of wholesome acceptance and belonging.

It felt good. Sturdy. Like something that could help me stand back up. If I were going to remain true to this pact I had made, I was going to need *a lot* of help. And I was going to have to somehow convince myself that it was time to not only get clear about asking for what I needed but also to position myself as ready to receive it.

I left the church that day with a renewed sense of purpose and hope. Even as I navigated the feeling of having

nothing and no one, I was reminded that God remained, and so did I.

I was still functioning, still breathing, with plenty to be grateful for. I had managed to work my way through my entire life, so I could make it through whatever was next.

> "Do you not know? Have you not heard? The LORD is the everlasting God, the Creator of the ends of the earth. He will not grow tired or weary, and his understanding no one can fathom." —Isaiah 40:28

And maybe, now that I had some time to process it, just maybe the life I knew hadn't necessarily been *taken away from me*, so much as it had been *adjusted*.

It made me think of some scripture from Romans Chapter five that says, "We glory in tribulations also: knowing that tribulation worketh patience; and patience, experience; and experience, hope."

Maybe God was taking an eraser to the chalkboard and removing anything that was going to get in the way of me fulfilling the life I was actually meant to live, clearing space, and giving me a fresh start. Maybe this was not only a fertile place to build from but precisely where God needed me to be.

I got into my car and called my favorite sushi place to put in an order. As the phone rang, I thought through the significance of where I was in my life. Somehow, picking up takeout and heading home to binge-watch television didn't seem so daunting. Suddenly, it was ... exciting?

It was as if a heavy veil had lifted, revealing the truth. And the truth in that moment was that I was in a place in my life where I did not anticipate being.

For the past several weeks, that place had felt like the end of it all. But something about today felt different. It felt right. It felt lighter, and I was feeling more optimistic. It felt like a beginning.

As I drove home, I latched onto the idea that there were a lot of things to look forward to. That the things I was upset about were illusions. I was upset about not being able to fulfill plans for the future, as if I were ever promised those plans or that specific future in the first place.

I was concerned for my children, as if they weren't more resilient than me. I was worried about my reputation, my identity, and being alone, as if I were the first person on the planet to ever experience a divorce.

Instead of dwelling in the dark, I started thinking to myself, *What if God actually has something way better in store for me? What if this is all part of a plan that I am not privy to just yet? What if my choice to resist this change is actually keeping me from what God has for me next?*

I smiled through my COVID-mandated mask as I picked up my sushi and turned on an old playlist as I drove the rest of the way home. The food smelled good, and the sky looked bigger. I was looking forward to getting home and enjoying my night.

I waved at my neighbor as I pulled my car into the garage and gently touched the canvas photos on the floor as I walked by them and into the house. I set the food on the kitchen counter and decided that before I got cozy with my sushi in front of the TV, I'd rinse off and change into something comfortable.

And then, for the first time in weeks, I took a shower.

CHAPTER TWO

THE SPACE BETWEEN

"What you're referring to is liminal space," my therapist said.

"Can you spell that?" I asked and did a quick internet search.

> *Liminal space refers to the place a person is in during a transitional period. It's a gap, and can be physical (like a doorway), emotional (like a divorce) or metaphorical (like a decision).*[1]

I had never heard this term before. *Liminal space.* But this is the term my therapist gave me to help explain what I was experiencing. I was thankful for the awareness of being in between chapters of my life, and knowing there was an actual word for it helped me to feel even better. If this thing already existed, and my therapist was sharing the

I was thankful for the awareness of being in between chapters of my life.

details with me, that meant I wasn't the only person in the world navigating it.

I started to dig deeper into what others were saying about liminal space as it pertains to its emotional and metaphorical applications. I found plenty that connected liminal space with emotions like *anxiety*, *uncertainty*, *stress*, and *overwhelm*, but nothing that connected it to the feelings I was starting to have: *excitement*, *positive anticipation*, and *optimism*.

There was no doubt that I understood the relation of liminal space to an unpleasant experience. I mean, I had just spent what felt like months incarcerated in my bathtub because I couldn't see past my pain and problems. In fact, I couldn't recall a time in my life when the change or transformation *wasn't* difficult, especially when it was unexpected, and *definitely* when it involved other people.

These feelings of being stuck and on a hamster wheel were exacerbated by what I refer to as the Self Help Spiral. This is the endless roller-coaster ride of reading the books, buying the courses, listening to the podcasts, attending the events, knocking out therapy sessions, and whatever else you can think of without ever actually taking action towards the direction of the desires of your heart. For years, I knew things were off; I knew I was abandoning parts of myself, but I wasn't yet totally ready to take action. I wasn't yet confident enough in myself to pull the trigger in any particular direction, and life (up to this point) hadn't yet demanded that I step up and make something different happen.

After years of spending time and money, traveling across the country and searching for answers and validation from other people, wasting time in this endless Self Help Spiral, I realized that not only was I the only one responsible for initiating change in my life but also that I had actually been carrying the keys to my own freedom all along!

> I realized that not only was I the only one responsible for initiating change in my life, but that I had actually been carrying the keys to my own freedom all along!

THE BUTTERFLY

Several years ago, my ex-husband, Nate, and I were in Lake Tahoe to celebrate our anniversary in the same place we had our honeymoon years prior. Only this time, our life and our love looked much different.

Things hadn't been great in our relationship, but we hadn't yet reached the worst of it. Looking back now, I think this trip was our last-ditch effort to really make things work, even though there were many signs pointing to the reality that it wouldn't.

We had just finished lunch at a small restaurant in South Lake Tahoe. It was fall, and the air was crisp as we made our way out to the parking lot. We had been staying at a cabin in Crystal Bay and rented a BMW street bike to take a ride around the twenty-two-mile-long lake. As we were

suiting up for the ride back to our cabin, out of the corner of my eye I caught a glimpse of a tall red sidewalk flag outside of a shop across the lot from where we had parked.

The words on the flag announced, "GALLERY OPEN." Behind it, a sign hung in the window with the words "JIM CARREY—Artwork on Display" printed on it. My heart skipped a beat. I had been a fan of Jim Carrey for years but became fascinated with him in a new way when I heard the commencement speech he delivered for the graduates of Maharishi University in 2014.

It was during that speech I learned he was much more than an actor; he was an artist and an inspirational speaker who says things like, "I'm just making a conscious choice to perceive challenges as something beneficial so I can deal with them in the most productive way," and, "Risk being seen in all of your glory." And that day, by total chance, I was going to get to experience some of his art in person.

> "Risk being seen in all of your glory."
> —Jim Carrey

Recognizing my excitement, Nate put his gloves and glasses back into the storage compartment of the BMW and walked towards me. As we approached the door, we were invited in by a gentleman with a friendly smile. He introduced himself as Lloyd and directed us to where Jim's work was located.

I had never really been to this kind of gallery before, one with fine art consultants and price tags that end in five zeros. I made my way through each piece, taking a moment

to absorb the art and honor the artist. Then, I found myself smack-dab in front of a piece created by Jim.[2]

After several minutes of silence with the painting, Lloyd approached me and asked, "Would you like to see it in the proper lighting?"

"Sure," I replied.

I stood back while he carefully removed the piece from where it hung in the main lobby and led Nate and me into a small, faintly lit room where he placed the piece on the wall in front of us.

"This way," he whispered as he made a few last adjustments, "you get to experience the art free from other distractions."

With Nate standing next to me, I closed my eyes for a few seconds so that they could adjust to the light. I took a deep breath. When I reopened them, the painting I saw in front of me was much different from the one I had seen moments earlier in the lobby.

I stared at the painting. My focus went to the butterfly—black and white, perched atop the finger of a man behind bars. His body and face are out of frame, his hands dangling and defeated, connected to arms that slink into the darkness. This person was contained, held back, limited.

Something about the dark purples and blues in the background made me feel sad because I understood what it felt like to operate within the confines of societal expectations, to have parameters and responsibilities, to sacrifice parts of myself for those I loved. Although they were all my choices, to act and be as I had for so many years,

they were choices that brought me to a place that didn't feel good, that made me feel small, defeated, and confined.

But then, there was the butterfly, outside of the bars, highlighted in bright yellow, free to fly, to explore whenever and wherever it pleased. To me, it represented hope, the relief of a better, brighter future, one of limitlessness and opportunity.

Lloyd adjusted the lighting again, and the light blue words that overlaid the image were brought to the forefront: "... and in that moment he was freed from the prison of becoming."

Suddenly, something about this seemed so ... spiritual.

I felt a sense of overwhelm. Hot tears welled up behind my eyes. I had never felt so connected with a piece of art in my life. It was as if everything had disappeared and all that was left on this earth was me and this painting. I tried to hide my emotion and found myself wondering if Nate or Lloyd had noticed. Thankfully, the light and their focus were on the painting and not on me.

After a few minutes, we exited the small room and followed Lloyd as he returned the piece back to its original display. The title of the piece: *The Prison of Becoming*. The description next to where the painting hung read:

> *To spend one's life yearning to be something better or different than who we are at this moment is to be locked in a state of perpetual becoming. It is a sentence that robs most human beings of their spiritual freedom. Heaven is the quiet butterfly-like transformation from the incarceration of the mind*

to the purity, freedom, and weightlessness in the conscious awareness of presence. —Jim Carrey

Somehow I had found *myself* in a Prison of Becoming. Since becoming a mother, I felt torn in too many directions to count. I felt alone in the experience. I was constantly anxious and felt guilty for wanting to have alone time when I had beautiful and healthy babies who needed me.

I wasn't able to give anyone or anything my full attention, which left me feeling pathetic and nonproductive. I left my career to be home with my children, which left me feeling like a failure, like the hard work that I had put in and the career goals that I had set no longer mattered. I defaulted to a fragmented version of myself, where I operated on autopilot and tried my best to remain sane, to fit into the role that my circumstances presented me, and to pretend that everything was okay.

Inside, though, I was in this perpetual cycle of wanting *more*, feeling like I had to *be more*, looking far out into the future to the day I would finally become and have *enough*. And when I *would* finally become enough, it would only make sense that my to-do list would be shorter, my health would be better, and my life would be easier. I would finally have all the things I needed to feel happy and successful.

Until then, I would continue to wake up each morning, walk myself into my cage, and lock myself in. Why? Because it felt familiar to me, and I was well-acquainted with my cellmates. Why make friends with new things like trusting myself, being disciplined, taking action, and connecting with others when I already had such long-standing

relationships with anxious thoughts, worries, fears, and uncertainties?

Plus, my environment at the time wasn't conducive to growth and change. While I was always pushing and working towards more, those in my circle were wondering if I'd ever be satisfied and why I wasn't just grateful and content with what I had. Because of this, I picked up a negative inner dialogue that began to find the benefits of playing small and giving up on my dreams. *If I never become successful, I can stay behind these bars and it would be acceptable for me to blame my circumstances.* But was it worth feeling like a prisoner?

The reality was, I had totally abandoned myself and my needs. I was longing for the day that I would feel whole again. I had actually convinced myself that the captivity I kept myself in on a daily basis was protecting me from something worse. I would tell myself that this was where I needed to be, that everyone goes through this, that it was normal and I should just accept it.

> **I was longing for the day that I would feel whole again.**

But as I stood there in that fine art gallery, in front of that painting, I realized everything I had conjured up was counterfeit. I wasn't protecting myself from anything. What I was experiencing *wasn't* normal. And there *was* more to life than what I was being told I had to endure. It was as if I was in shock. So many thoughts and feelings were firing in my body. Dots were connecting, and things

were snapping into alignment. I was experiencing a literal epiphany … an epiphany I had to remind myself of less than a year later when I was in weekly therapy, navigating the fallout of my divorce.

I took another sip of my coffee and stared at my therapist's face on my computer screen. "I don't want this to be difficult anymore," I said. "I want to consciously choose to see this experience as something I can leverage, something that will make me better."

I didn't want to slink back into the blues and purples of my life, back into the darkness. I wanted to be like the butterfly. I wanted to risk being seen in all of my glory.

CHAPTER THREE

THE LIMINAL ADVANTAGE

SELF-PITY

I never saw a wild thing
Sorry for itself.
A small bird will drop frozen dead from a bough
Without ever having felt sorry for itself.
—D. H. Lawrence

Staying confined was easy, and for quite some time early in my divorce, I preferred it. I knew I could choose to wallow in the place I had landed and easily soak up a solid year (or two) in the recovery, and it would be completely acceptable to those around me. The biggest problem with that, though, is that *I* didn't think it was acceptable. What good was going to come from staying stuck?

It seemed way more logical to me to frame my experience as something to leverage versus something that was going to totally destroy me. Not to mention, I had two young children depending on me. As a mother, failing was

not an option. Giving up was not one of my choices. Pity parties in the bathtub were no longer going to be the routine.

Giving up was not one of my choices.

But as I learned about the term "liminal space" and the angle from which I had begun to approach it, I realized it was my secret weapon. This was the tool that was going to change my life and permit me to take agency, to make new choices, and to end up somewhere different—somewhere I actually wanted to be.

THE LIMINAL ADVANTAGE

It seemed that the rest of the world looked at liminal space as a curse, while I had grown to see it as an advantage. I was done with difficulty. I was done with being tired. I was done with not defending myself, my beliefs, or the type of life I wanted to live. I was done feeling guilty, unlucky, and depressed. Instead, I made a decision that I was exactly where I needed to be and that every experience, every feeling, every setback, and every gift had perfectly positioned me for my next move. I had discovered the Liminal Advantage, the concept that would launch me forward and change my life.

I had witnessed so many people in my life remain trapped by their circumstances, caught up in their stories. Throwing their own fears and limiting beliefs over themselves like a comforter every night before they went

to sleep, only to dress themselves in the fears and limiting beliefs of others as they drank their coffee in the morning.

Growing up, I watched my parents sacrifice tremendously so that my sister and I could have the childhood they wanted us to have. I watched my friends jeopardize their integrity and sobriety to try to fit in. I watched my coworkers go through divorces, long-distance relationships, and navigate challenges that attacked their character.

From a young age, I had exposure to a variety of circumstances, which allowed me to gain an understanding of situations I may have never gone through myself. Having the ability to observe and become aware of these issues gave me access to lessons learned that I would apply as proactively as possible in areas of my life when needed. I also had encyclopedias full of failures and mistakes from my own life experiences that I tried to not repeat.

As I found myself navigating my current situation, even on my worst days, I shuddered at the thought of permitting myself to subscribe to the idea that my circumstance somehow gave me an exemption from doing my best, trying my hardest, and fully relying on God.

Not to mention, my problems seemed small compared to what was happening in the world around me.

FORCED TO PIVOT

News stories were covering mass school closures, grocery stores with armed guards, and cities that looked like ghost towns in other parts of the world—far away from where

I was. Slowly, though, the effects of the pandemic were spreading to my area, and we all were forced to pivot. People all over the planet were being deprived of their basic needs in a matter of weeks—needs that, up to that point, had been regularly satisfied without much thought and that most of us had totally taken for granted.

This widespread shortage of supplies, hope, and answers reminded me of a paper I wrote in college on Maslow's Hierarchy of Needs. Abraham Maslow was a psychologist who, in 1943, developed the Hierarchy of Needs, a concept that identified what he believed were the categories of fundamental needs required by humans to reach their potential.

I had been fascinated with Maslow's perspective on psychology, motivation, and self-actualization since I was a teenager and found myself living in the exact opposite of what he referred to as *Eupsychia*—a psychologically healthy Utopia. So, not just a society where the population has all of the money and material things, but the mental, emotional, and spiritual things, too.

It was safe to say that as each day passed, we were taking monumental, collective steps that took us further and further away from what we had experienced as normal, which was far from Eupsychia to begin with.

What started as an experience that "others" were having started to hit home when I was at my self-employed friend's business on the day he was informed that his very successful company was deemed non-essential. This meant he had to cease operations immediately and indefinitely, which included laying off his employees, who were the sole

income providers for their families. Like countless other business owners, he later filed for bankruptcy.

Hand sanitizer, masks, and toilet paper became the hottest commodities—people fighting over them in stores, driving prices for such basic supplies up higher than ever before and making them unavailable to many.

Friends of mine were visiting ill family members through the windows of hospitals—hospitals that were stuffed full of patients but running low on staff and equipment.

Our families and communities were practically ripped apart overnight. Even healthy family members were told not to gather, hug, or shake hands. Our sense of belonging and connectedness to one another became skewed and lacked depth. The fear of the unknown upstaged generation-long relationships, and we were forced to choose between things we never imagined we'd have to.

We began to navigate how to work from home, manipulate technology, and combat the villain that was COVID-19.

We started hearing things like "the new normal" and "pre-COVID"—our world time-stamped by the onset of this outbreak.

No one had the answers; no one knew what was next; no one was prepared.

Questions surrounded the things we prioritized as most important: our jobs, finances, homes, and most precious of them all, our health.

The world suddenly required us to experience life without all of the things that we were attached to, the things many of us really needed.

No traveling for those who were accustomed to being on the go.

No shopping for those who found pleasure in spending.

No gym access for those who couldn't miss a day.

No connection for those who were used to handshakes and hugs.

No school for the parents who were used to accomplishing what they needed to during the day while their children were taught face-to-face in classrooms.

No space for spouses who were used to separate workdays and then returning home for dinner.

We went from operating according to our regularly scheduled programming to operating from a deficit, what Maslow would refer to as *operating from deprivation*, in response to our deficiency needs or "D-Needs." These are the needs many of us are familiar with from Maslow's popular hierarchy.

SELF-ACTUALIZATION
desire to become the most that one can be

ESTEEM
respect, self-esteem, status, recognition, strength, freedom

LOVE AND BELONGING
friendship, intimacy, family, sense of connection

SAFETY NEEDS
personal security, employment, resources, health, property

PHYSIOLOGICAL NEEDS
air, water, food, shelter, sleep, clothing, reproduction

MASLOW'S HIERARCHY

Maslow proposed that people were motivated by particular categories of needs and that in order for a person to reach their highest potential, these needs must be met in a consecutive order—starting with physiological needs (things like food, water, and shelter), working up the pyramid to self-actualization (which, to me, means reaching your peak potential and living from a state of overflow).

But here we were in 2020, not just a small group of us, not just a few thousand or tens of thousands of us, but the majority of the world—suddenly experiencing material lack and uncertainty, which festered into psychological lack and uncertainty. Very few of us focused on self-actualizing; most of us focused on simply surviving.

Our entire societal framework was dismantled.

We were all required to pivot. Immediately.

With the pivot, there was panic. The panic turned into anxiety.

The anxiety turned into loss of control. The loss of control turned into despair.

Emotions and behaviors that had been collectively shoved down for generations were finally rising to the surface. All of our go-to coping mechanisms were out of the picture. We were faced with making serious decisions and making them *now*.

The effects of the pandemic seemed to drive us down a narrow corridor where we could no longer run from our struggles. Relationships were strained. Bank accounts

drained. Plans postponed indefinitely. Babies were born under desolate circumstances, and people were unable to say goodbye to their loved ones.

The things we needed and once had access to were no longer available. Our material requirements were limited and hard to access, our psychological needs went unmet, and many of us became unstable. It was practically impossible to feel human, let alone self-actualized, when we had no sense of safety, connection, or confidence.

As a country, we were required to readily respond to something we didn't expect and knew nothing about with resources we didn't even have. For many of us, the narrow corridor became tighter by the day, suffocating, even. We hadn't realized we were claustrophobic until this moment, standing helplessly, our gaze focused ahead, anxiously awaiting some source of light at the end.

We were in crisis and experiencing, on a large scale, what it was like to be in the thick of a transition period, in the midst of liminal space.

It was as if the entire world was experiencing the same thing that I was in my own life: a realization that we had come into a time that would affect and define us forever, not just collectively but individually, too.

This global shake-up slung all of us into situations we had not anticipated while simultaneously offering us an opportunity to leverage our own Liminal Advantages.

Maybe the corridor wasn't that narrow.

My perspective began to shift. Instead of looking down a long, daunting, endless path ahead, I found myself wanting to run down the hallway, opening all of the doors,

flinging them open excitedly one by one, my actions fueled now by curiosity instead of fear.

Maybe what we had been prioritizing and what had been motivating us up to this point were the wrong things.

Maybe Maslow was right—that a utopian society of "perfection" meant nothing without our physiological and psychological health.

And maybe the life we knew pre-pandemic hadn't necessarily been *taken away from us*, so much as it had been *adjusted*.

Would we be willing to replace the things we lost with the things we *really* needed? The things we really cherished?

What if space was being cleared, giving us a fresh start?

What if this was a fertile place to build from and we were being perfectly positioned for our next move?

CHAPTER FOUR

THE PACT

The decision to lean into my Liminal Advantage and relentlessly pursue myself consumed me.

It was easy for me to feel trapped, stuck, and confined before. Buried instead of planted. But now, I could see that I was being methodically and especially prepared for my own unique future. For months, I had been letting things go—my bills, my house, *myself*.

I had to get real. I had to wake up. I had to get clear about how I was spending my days so I could get intentional about what was upcoming. I grabbed my laptop, a notebook, and a pen as I made my way to my dining room table. If I were to continue to move forward with this God-ordained pursuit that I was so perfectly positioned for, I would have to get serious. I would have to have a plan. *I would have to be an adult.*

I waited for my coffee to be ready and parked myself in front of the open refrigerator. Nothing. I opened the freezer. Hot Pockets. Perfect. Nothing says *adult* like a Hot Pocket. I tossed it in the microwave and grabbed the stack of mail that had been sitting on the counter.

I knew my entire life wouldn't change overnight, but I also knew the significance of baby steps and small wins. Thanks to my weekly therapy, I was becoming aware of the minor changes I was making as I was able to make them, and I did not want to start judging myself now. Regardless of how large or small the steps I was taking were, they were adding up to progress, and that was what was important.

> "You intended to harm me, but God intended it all for good. He brought me to this position so I could save the lives of many people. Don't you see, you planned evil against me but God used those same plans for my good, as you see all around you right now - life for many people." —Genesis 50:19-20

I prepared a workstation for myself, complete with my coffee and Hot Pocket, and was ready to roll. Nothing was going to get in the way of me overcoming this part of my life. I knew in my bones that God was weaving it together and would use it for good. Finally, I felt like I was getting somewhere.

Feeling borderline invincible, I took a sip out of my favorite mug. Whatever I was about to do, it was going to be life-changing.

Holding the Hot Pocket in the cardboard sleeve, I took a bite and immediately spit it out, tossing the remaining portion onto the table in Jesus's name. I had just experienced my first spiritual attack—a third-degree burn to the roof of my mouth.

I took the Hot Pocket and broke it in half to cool. And would you believe that it was still ice cold inside? I stood up, and out of my flow, went back to the microwave.

As I waited for the timer to count down, I had a thought about how sometimes, *we* are like Hot Pockets—hot on the outside but cold in the center. Presenting as one thing but being something else inside. Frozen one day, on fire the next, sometimes wishing we were either one or the other. Or worst of all, we are lukewarm. Half alive, neglecting God, and barely tapping into our potential.

I realized, though, that at this moment, nothing about me was lukewarm. God had been preparing and equipping me for quite some time.

I wasn't a plate of leftovers, tossed into the microwave for thirty seconds, coming out with a cold center. In His eyes, I was perfectly prepared, more sous vide than microwave.

Sous vide (French for "under vacuum") is a term used to describe low-temperature, long-term cooking where food is placed into a protective covering, like a plastic pouch or glass jar, lowered into a pot, and cooked in a water bath set to a precisely regulated temperature for longer than usual cooking times.

I could not find a better way to explain the preparation I felt I had experienced.

It was like God placed *me* carefully into a protective covering, sealing it shut so nothing could interfere with His plan for me. Then, I was lowered into a pot of water set at a temperature specifically for me and left there until I was ready.

Sometimes, it felt too hot. Sometimes, it felt too long. Sometimes, it felt like God had totally disappeared and forgotten me.

But, it was never too hot or too long—and I was never forgotten. All of the settings were perfectly and strategically dialed-in for me.

> "But blessed are your eyes because they see, and your ears because they hear." —Matthew 13:16

It was me that was still cold inside. It was me that was impatient. It was me that was lukewarm.

God had been preparing and equipping me for quite some time, all the while protecting me, too. And now, I had the eyes to see it.

The microwave beeped, and I returned to the table. This time, the Hot Pocket was steaming hot, and I was ready to dive into my first order of business—which was to approach this pact with a new sense of intensity and enthusiasm. I wanted to take the visions in my mind and the desires God had placed on my heart out of my imagination and make a plan to bring them to life.

I wanted to create my own season of transformation. I was tired of feeling like a victim and tired of abandoning the parts of me that longed to be seen. I refused to continue to be lukewarm, to half-heartedly commit to myself and to what God had in store for me. I wanted to create balance and make progress. I wanted to leverage everything that had brought me to this very moment as momentum that would catapult me into a life I couldn't even begin to imagine. I wanted to fail forward, no matter how much strength or how much time it would take. I wanted to get specific about this pact I was making and I knew in order to do that, I'd have to get clear about how I was spending my time.

REDEEMING VS. SPENDING

Prior to the pandemic and my separation, my days were jam-packed with all kinds of things. Most days, I was living by default, letting other people's demands drift me away until I would land somewhere unplanned. The days were spent and spoken for before I even got out of bed in the morning. I was busy all the time but rarely felt productive or satisfied. I was spending my time on things I didn't enjoy, with people who weren't good for me, doing many things I didn't even want to do.

But now, I wasn't leaving my house to work, had zero errands to run, everything was closed, and everyone was under the same quarantine orders I was, anyway. Oh—*and*, since I had successfully removed pity parties in the bathtub from my schedule, I had six hours a day now free for the taking, on top of the time available I typically spent feeling sorry for myself and stressed out.

> **I had the opportunity to redeem my time carefully instead of spending it wastefully.**

I had a blank slate to curate a day full of purpose. I had the opportunity to *redeem* my time carefully instead of *spending* it wastefully. I'd be able to intentionally craft a way to prioritize the things that meant the most to me personally and to actually tell my time where to go.

The Bible tells us in Ephesians 5:16 to "redeem the time because the days are evil." I was first acquainted with this idea when I heard a sermon years ago. In it, the pastor

challenged the congregation to "take inventory of how you're spending your life." As he referred to 1 Corinthians 9:26, he said, "On a regular basis, you need to re-evaluate what you're doing and how you're spending your time. Refocus your life. Let go of any distractions. Shake off any self-pity, any discouragements, any disappointments, and run your race with purpose."[3]

I took another bite of my Hot Pocket, opened my notebook, and wrote the time I had been realistically waking up in the morning at the top. At the bottom, I wrote the time I had usually been going to sleep.

And then, I stared at the blank space in between.

Up to this point, I really hadn't been spending my time doing much of anything. But I was honest as I filled in the blank area with my current reality. I began to realize how frivolously I was spending my time; I was aimless and wasteful.

> "So teach us to number our days that we may get a heart of wisdom." —Psalm 90:12

How much work God must have had to do in the background to clean up my mess and turn this around for my good! I was dedicated to numbering my days in a new way.

I started thinking about the way I wanted my life to look. Taking my personal priorities into account, I began to outline a framework for my days that allotted time for what I valued most.

It was obvious by this point that whatever I would choose to put into that space would dictate my days,

but I was starting to understand that each of these days strung together would then dictate my weeks, my months, my years.

I didn't want to continue to live an overbooked life full of panic and stress.

I wanted quality over quantity. I wanted what *I* wanted, what God had set aside just for me, not what society and others had previously pressured me to want.

I wanted to have fun, to fall back in love with my life, and to have time for the things that helped me to be the best me, no matter how ludicrous or minuscule it would seem to anyone else.

PERSISTENTLY ALIGNED COMMITMENT TO TRANSFORMATION

The usual definition of a pact equates to an agreement or contract. The beautiful thing about *this* pact, though, is that it doesn't necessarily need many parameters. As I sat down and came into agreement with what God wanted most for me, it was more of a surrender and a trusting than a contract.

Instead of a transactional agreement, it was more of a pledge or a vow to always continue to pursue the person that God intended me to be. To participate in a Persistently Aligned Commitment to Transformation. To never give up on that person. And to go back in time and deep within to rescue the versions of her that had been scared, shamed, shoved down, and forgotten.

In this section, I will share some insight into how you can get clarity around the promises you want to make to yourself, the pact that you'd like to make as you come into agreement with God's plan for you.

Persistent

When I think of being persistent, I think of perseverance, continuing forward, never giving up. I think of relentlessness, of finishing what I start, being thorough and steady. Making this pact with yourself and with God will require you to be all of these things. You will be required to continue to show up for yourself in new ways, even when it is uncomfortable and scary.

Aligned

Being aligned with this commitment requires you to have a clear understanding of what you are aligned with. Your faith must be at the foundation. The pursuit of yourself must be the vehicle. And the vision you have for your life, the person you want to become, has to be the energy you are aligned with.

Without this alignment, without standing for something, it is easy to fall for anything, get distracted, and find yourself wandering along the broad road, heading towards the wide gate leading to destruction. The Bible mentions in Hebrews 12 that as we "run with endurance

the race that is set before us," we should "lay aside every weight and sin which clings so closely."

As my pastor once shared in a sermon one Sunday, these "weights" are the things that keep us from having the energy and discipline to be obedient to God. The sins that cling so closely are the sins we know get us every single time, the ones we fall prey to over and over again. Here, we must be clear about what these weights and sins are, to take the time to really evaluate our lives and become aware of them so that we can take proactive action to remove them from our lives and better navigate circumstances that arise that give us opportunities to backslide.

Commitment

Commitment—a hard word for a lot of us, especially when it comes to committing to ourselves. It doesn't always feel natural. In fact, most of the time it feels selfish. But I want to flip the script on the stigma that surrounds this lie. Committing to yourself is not selfish. It is actually the least selfish thing you can do. Without making commitments to yourself, how in the world are you supposed to function, let alone show up in the way you'd like to for others?

And just to emphasize the original intention of this pursuit, you are embarking on a journey to rediscover yourself so that you, too, can redefine your life. And I would like to believe that this book lands in the hands of good, heart-centered people whose pursuit is connected to a mission that is greater than they are—to be the best

parent, to be obedient to God, to be a role model for those in their life. Can this commitment lead you to a successful business? More money? More connections? Absolutely. Should we get swept away by these worldly things in lieu of chasing the person God wants us to be? Never.

Transformation

The importance of this part, the transformation, is that we have to acknowledge and accept at the outset that whether we want to or not, we will continue to evolve and change. The world around us will continue to evolve and change. And if we are too rigid, too caught up in our own ways, we will not be leaving room for God to work or for us to really explore and expand into our truest potential.

Many of us are missing the mark on happiness and success because we've never taken the time to get to know ourselves enough to identify what it is that we actually define as happy or successful.

We are too busy keeping up, comparing, and psychoanalyzing using a very limited scope with a dusty and cracked lens. Making this pact with yourself, with God, can rectify that. Committing to this journey is a way of uncovering who it is you really are—to peel back layers, build behaviors, and shine a new light on the person we ACTUALLY ARE—with an expectation to embody a confidence that is so unapologetic, so genuine, so true, so authentic, that there is no mistake about who you are and what you're here to do.

PART II

THE FIVE FACETS OF FULFILLMENT

Once I really anchored into my pact, I found myself teetering between the liberty I felt as someone who had been freed from her Prison of Becoming, sensing the opportunity and potential I now had to do all the things I always wanted to, and the grief—the painstaking, bring-me-to-my-knees, unbearable grief of losing the life and family I thought I was going to have.

As I sat there, considering what I would most want to fill that blank space with, I couldn't help but remember the hand I had been dealt. The truth was, I had become hopelessly and pathetically content with not talking to anyone, not getting dressed, barely eating, and exhausting my hot water tank. Even if lockdown orders were lifted, and I would have been able to get out of the house, chances are, I wouldn't have.

But I didn't want that life anymore.

And, although I knew I didn't want the kind of life where I wasted time on things that barely mattered, prioritizing my own victimhood and self-pity, I realized quickly that I had lost touch with what made me happy. It was as if I had totally forgotten who I was, which was alarming.

On the other hand, a blank slate meant opportunity, which was exciting. It became clear that in order to redefine my life, I would have to rediscover myself. Not who I once was, not who I was yesterday, but who I was right then in that moment.

I wanted to leverage where I was and do something with it. I wanted to move forward. I wanted it to be easy. But inside, I knew that wasn't going to be the case.

I thought of what Noah told Allie in *The Notebook*: "It's not gonna be easy. It's going to be really hard." I knew I'd have to work at this change every day. But I also knew if I could commit to that, it would be impossible for me NOT to experience some kind of results.

This wasn't just me making to-do lists, reading self-help books, and making vision boards. And it wasn't just about satisfying my basic needs in some kind of chronological order, as many of us think when we think of Maslow's hierarchy.

This was me digging deep into the mechanics of who I was, rediscovering parts of myself that had been dormant for so long, and finding pockets of potential that had never even been tapped into. Realizing that I was not just this two-dimensional checklist that needed to be fed, watered, and loved, but a multi-faceted person with my own fingerprint. One who was now solely responsible for keeping up with the groceries, home, bills, and more, day after day, while somehow still trying to enjoy life in this imperfect world.

As I became reacquainted with things I forgot I loved so much, things that I really couldn't afford to live a day without, things that helped me to live a life where I'd be bursting with fulfillment, distinct Facets of my life began to emerge, Facets I realized were not just specific to me, but to everyone.

Once I had a handle on these Facets and could name them—Schedule, Significance, Satisfaction, Senses, and

Spirituality—and I was aware of the ways my personal situation required me to tend to them, I began to gain new feelings of confidence and capability that I hadn't had in quite some time.

Establishing a relationship with each of these parts of my life and tending to them thoroughly gave me the feeling of a solid foundation I could build from. I was taking agency over my life and now had a system in place to help me maintain this order.

Simultaneously, I had energy available (the energy that used to be consumed by stressing over these things) to be creative, to think about the future, and to begin to create ways of reaching new goals that would take me to my next level.

It all started, though, with me sorting through the details of my life and myself until I was clear about how these Facets would be put into motion in my life. I had to find out more about who I really was. I had to do the work. It was the only way I could begin to find out what I truly needed so I could make strides towards creating a happier, healthier, more beautiful life, one that was conducive to experiencing satisfaction and self-actualization.

I trust you will quickly relate to these Facets of Fulfillment as I discuss them in depth in the upcoming chapters. You will see that they are based upon the needs we have as humans, as spiritual beings, and as people who are doing their best to navigate all of the components of living a life here on earth. Included here are ways for you to sort out what your requirements may be and how to set them in motion in your own life.

Then, we will discuss ways to remain consistent and organized when it comes to creating your Best Day, Every Day, while leaving room for you to evolve and for God to work. The goal is to think about each of these Facets from an ideal and unique perspective, without judgment.

On your *best* days, how do each of these Facets show up in your life? What do you, personally, need most out of each of these areas to have your Best Day, Every Day? Thinking this way will help you to determine the most valuable ways you can incorporate each of these Facets into your life so that you will be honoring your own identity, your own fingerprint, and becoming *actually* who you are *potentially*, with a sustainable structure for your life that is designed for you, by you. If you haven't already, grab a journal and get ready to rediscover yourself and redefine your life!

CHAPTER FIVE

THE FIRST FACET

SCHEDULE: THE STRUCTURE BY WHICH YOU REDEEM YOUR TIME

I realized early that I had to start with moments, that attempting to overhaul an entire day (let alone my entire life) was too overwhelming. I had to start with segments of the day, and I had to deliberately curate experiences for myself that I knew would make me feel better and more satisfied. It was too soon to come up with solutions to all of the problems in my life, but I *could* get behind the thought of stringing together moments.

I filled in the blank space.

Starting with the time I had been waking up, I began to outline my days, allocating ample time for me to do things that felt good, significant, and like a priority. As I strung together moments, so came a good morning. As I strung together good mornings, the afternoons were good, too. The good afternoons bled into the good evenings, and before I knew it, I had a good day. And then I had

the opportunity and the momentum to attempt to string together two days, then three and four.

Moving forward, I would only do things I enjoyed or that were otherwise productive to my livelihood—things like laundry, paying bills, grocery shopping, and the like. Now that I had this blank slate opportunity to curate my days in a new way, why would I ever backfill it with things that weren't important to me?

This included acknowledging the clamor—the ruminating thoughts, the emotional havoc, and the mental turmoil—that many of us experience regularly. Whether we fully understand it or not, these things take up time and space, too, and can exhaust us faster than I used to exhaust my hot water tank. And they have to go.

I had to remember that a spiritual enemy was on the prowl. The Bible tells us in 1 Peter 5:8, "... the devil prowls around like a roaring lion looking for someone to devour." Earlier in the chapter, it tells us to be sober and vigilant so that we can be aware of this threat that is among us.

It had become clear that I was not sober-minded nor clear-headed. How could I be when there was so much happening in my life, in the world? And to be clear, this sobriety had nothing to do with alcohol but everything to do with the fact that my mind had been overrun with anxious thoughts, my body overwhelmed with symptoms of depression, and my heart hardened and far from peace. Because of this lack of strength, discipline, and support in my life, I felt like I could have been devoured by the enemy in an instant.

I had to get to making decreasing or totally eliminating the clamor in my life a priority so that I could create blank

space in my life. I knew that if I were able to do that, I could harness the energy once used to tend to all the stressful, scary, high-maintenance, overbearing things for something greater.

Anything that was not serving the most virtuous and victorious version of myself (physical things, mental things, emotional things, and spiritual things) was going to be immediately hauled out and no longer included in the way I would spend my days.

Instead, I wanted to prioritize things like drinking my coffee on my porch each morning before the kids woke up, trying a new recipe at least once a week, curating a calendar full of all of my favorite things.

I wanted to evolve and expand, to finally create the life I had been keeping myself from living, and to experience the things I never used to have time for.

And while I was willing to give myself grace, to go easy on my own self-judgment, I was also ready to take on the accountability and responsibility that it would require to follow through with what I was about to do. And so should you.

Remember: this pact you're making is a promise to yourself to know you never have to feel insane again, fueled by the strength you'll get as you choose to reclaim agency over your life and commit to doing it differently. You will curate a life that is made up of as much joy, value, and love as possible and ditch the rest so you can focus on the most important part of this journey, which is to create space for you to have a more *fulfilled* life, not just a *full* one.

TIME INVENTORY TOOL

Step One: Creating Your Time Inventory

That day, as I sat in my dining room, focused on the pact I had made, dedicated to redeeming my time in a new way, I developed what I now refer to as my Time Inventory Tool. Step One in this tool is outlining your Time Inventory, which is how you are currently spending your time. Once you get your typical day outlined, we will move to Step Two, which is where we will categorize your time (more on that soon). If you're a recovering perfectionist, like me, you're going to be tempted to make your Time Inventory look immaculate, like you're doing all the right things at all the right times.

But the only way this tool works is by being super honest with yourself about the way you are currently spending your time, from the moment you wake up to the moment you fall asleep.

Some days may look different from others due to family custody schedules, work schedules, or the fact that weekends are different from weekdays, and that's okay. Take time to mentally sort through your days, or even take a look at an existing calendar, if you keep one. Ultimately, you just want to be very clear about how you are spending your time.

- ▶ Grab your journal or a sheet of paper.
- ▶ Write the time you (realistically) wake up each morning.
- ▶ Write the time you (realistically) go to sleep.

- ▶ Fill in the space in between as honestly as possible.
- ▶ Create templates for days that look the same (weekends versus weekdays, days you work versus days you are off, days you go to the gym versus days off from the gym).

Do not over-complicate this.
The pivotal questions here are:

- ▶ What time do you wake up?
- ▶ What time do you go to sleep?
- ▶ And how do you spend the time in between?

Step Two: Categorizing Your Time Inventory

The next part of creating your Time Inventory is to categorize the activities you do regularly so we can get clear about what will stay and what will go.

Like the statue in Chapter One, we are breaking down the pieces of your day, shattering the way you have, up to this point, thought about spending your time. Once we get a clear understanding of what you value most, we will then pick up and re-integrate the pieces that are worth salvaging, that are lined up with who you are and the person you are pursuing.

We will begin with something simple: breaking down the things you typically spend your time on into two basic categories:

1. Things you enjoy
2. Things you don't enjoy

Things you enjoy

Activities that would fall under this section are things you genuinely couldn't imagine living your life without, things that light you up, make you smile, and warm your heart. The goal will be to have days full of the things you identify here.

Things you don't enjoy

Many of us spend our time doing a lot of things we do not enjoy. Identifying things that you don't enjoy does not make you a bad person and wasting time judging yourself over this part of the activity, or lying to yourself about whether or not you do enjoy something, is not going to be helpful here. Things you don't enjoy are things you don't enjoy. Simple as that. You won't have to validate your choice or explain your reasons why later. You will be challenged, though, with removing as many of these from your life as possible.

You'll see that in addition to things like your current job, the obligations you have with certain friends or family, or the awareness of your participation in unhealthy activities or behaviors, many of your day-to-day tasks may also be included in this category. And unfortunately, many of those things cannot just be removed. Instead, I'd like you to utilize this subcategory, discussed next, to help you outline the value of doing some of these things and categorizing them as "Things that are otherwise productive or move the needle in your life and/or business."

Things that are otherwise productive or move the needle in your life and/or business

Things that fall under this category for me include errand running, chores, operational parts of my business, regular business correspondence, etc. I'd be lying if I told you I enjoyed all of this and couldn't wait to wake up in the morning to pay bills, do laundry, and attend meetings that could be emails.

With that being said, I *do* find value in these things because, when done consistently, they provide me relief in knowing that things are under control. But, in the moment, I hardly ever actually want to *do* any of it. These are things that we will later find ways to make more efficient or to potentially subcontract them out so that they are still getting done, just not by you.

Now it's time for you to categorize your Time Inventory.

The most efficient way I have found to categorize my time is to lay it all out on paper. Typically, I'll use a green highlighter for the things I enjoy and a red highlighter for the things I don't enjoy. Then, as I review the things I don't enjoy, I'll differentiate the things that are otherwise productive or move the needle in my life and business by placing a star or checkmark next to them. This way, the way I'm spending my time becomes visually obvious and I can better comprehend what is happening so I know which action to take.

▶ Grab your Time Inventory from Step One.

- Categorize your Time Inventory utilizing the following three categories:
 - Things you enjoy.
 - Things you don't enjoy.
 - Things that are otherwise productive or move the needle in your life and/or business.
- Review your Time Inventory, taking a moment to notice any patterns or anything that stands out.

You may be surprised to see something that I am already well aware of: you are spending a whole lot of time on things that you don't enjoy OR you have a lot of time unaccounted for, time that *really is* being wasted.

Don't judge yourself. Look at this with a fresh set of eyes and an encouraged spirit. Just observe. Observe the way you spend your days as you continue reading. It'll be important that you have an understanding of your current schedule so that when we revisit this later, you'll know exactly how and where you'll need to make some adjustments.

Realize this is the first step of redeeming your time (and your life) in an entirely new way. As we move into the next chapter, I'll be introducing you to the Second Facet, Significance, which will help you to rediscover the things you value, prioritize, enjoy, and fear so that you'll be fully equipped to design your days with the things that matter most.

CHAPTER SIX

THE SECOND FACET

SIGNIFICANCE: A WORD DESCRIBING THE THINGS WHICH MATTER MOST

Recently, I posted a question on social media that challenged the audience: *Do you show up for yourself the way you do for everyone else?* And the response from the majority of people was *no*.

In fact, a man replied in the comments, sharing that for decades, he hadn't "permitted himself the luxury" of showing up for himself because he had been busy working multiple jobs to provide for his daughters as they grew up and went off to college.

Maybe you can relate. I know that I witnessed my parents do this and have heard stories about how theirs did, too. And as much as I genuinely appreciate everything those before me have done and sacrificed that has set me up for the foundation that I have had, I'm not sure I agree with it.

If it were up to me, I would have never wanted my parents to sacrifice their happiness or something they enjoyed or valued for me. I would never have expected them to stay together in an unhappy marriage for my sister and me if they'd had an opportunity to be happier sooner. I never want my children to have to choose between doing something they feel obligated to do versus something they want to do from a place of passion. Because when these decisions are made, they inevitably lead us down a path of spending our time in ways that are 100 percent not good for us.

You need to know that *values are not a luxury; they are the condition of the present*. If you value it, it should be a part of your everyday experience, not something you hold off on or experience only during special occasions or "one day."

Yet, I witness this repeatedly as I see people prohibiting themselves from experiencing the things that they actually *want* to experience for whatever made-up reason they think they have.

DESSERT BEFORE DINNER

It's like eating your tiramisu before your chicken parmesan at that fancy Italian restaurant in your hometown. It sounds ludicrous. For some of you, eating at a fancy Italian restaurant is off the table in general, let alone having your dessert before dinner. But what I am trying to convey is that we actually *can* have our dessert before dinner.

We can drop all of the ridiculous contingencies and give ourselves permission to have the "reward" before the hard work, especially when what we are defining as a reward is simply part of what we value, and what we value is a condition of the present—not a luxury.

Are you showing up for *you* the way you do for everyone else? Or, have you up to this point, considered showing up for yourself to be a luxury? Are you able to identify things that are significant to you? Are you even aware of what it is that you truly value most? And if so, are you prioritizing these things that are of significance?

The best way to answer these questions is to review your Current Time Inventory and see for yourself.

DISCOVERING WHAT YOU VALUE

When discussing *value*, I am referring to something you consider important, something you have respect for, cherish, something that is "worth" something to you. *Priority* refers to the urgency or the order in which the things you value are ranked.

Early in my work around personal prioritization and fulfillment, I became fascinated with the reality that the majority of people I knew lived a life that did not exhibit behavior that prioritized what they valued. Instead, they spent most of their time doing things they didn't enjoy. Observing people live this way was akin to bearing witness to the voluntary shredding of hundred-dollar bills. Through a variety of experiences and conversations,

I realized that ultimately people spend their time this way for three overarching reasons:

1. They don't know what they *do* enjoy.
2. They believe that a life of doing things they enjoy is not available to them.
3. They are unaware that they are operating from a deficit.

When I started to observe and study more of this type of behavior, I witnessed and realized that people believed several things:

1. It is absolutely necessary to pay your dues doing things you do not like to do so you can, maybe one day, do things you do like to do. (Pay your dues.)
2. Unlimited freedom and happiness are only available to a certain kind of person. (Keep dreaming.)
3. Striving for more only causes more problems, so you should probably just be happy with what you have. (Stay small.)
4. It is safe to stay within the parameters of what your immediate family and friends have done or believe—anything outside of that is scary, risky, and would force you to be on your own. (Stay safe.)
5. You get to experience goodness, happiness, and what you enjoy only after an immense amount of some sort of work or accomplishment. (Work hard.)

The interesting part about these beliefs is that while they make sense and provide a sense of pride and safety for some people, for others, having these beliefs feels more like a cage. If you're reading this book, it is likely you are feeling caged and limited—and if you resonate with that, I understand.

I spent many years of my life wondering why I saw things differently and wanted more in certain areas of my life. Being in proximity to people who have these false beliefs, when you find yourself on the polar opposite of the scale, can be difficult and detrimental because they are core, fundamental beliefs that set the stage for the most important life decisions people have to make.

And when you are up against an unsupportive environment and the fiery darts of the enemy, it can feel extremely hard—almost impossible—to break free. What you need to know here, though, is that none of these beliefs need to apply to you, and they can be totally obliterated.

I used to rely on these statements so much that they were part of the way I functioned. They began as ideas planted like seeds and were woven into my being with the circumstances that made up my life.

> "She is clothed with strength and dignity; she can laugh at the days to come."—Proverbs 31:25

And I believed them.

Or rather, I believed them *until I didn't*. And I quit believing them when I started to find others who didn't

either. Today, these statements are laughable to me. They are totally and simply false.

The most effective way I found to combat this lack mentality was to rediscover what it was that I *really* valued, what it was that I knew to be true. As I became more clear about those things, by default I began to collect evidence to support them. And when you are clear about what you believe and value, and have evidence to support those beliefs and values, they become priority.

As we move on through this process, I want you to get crystal clear about what it is you value most in your life. These values may change over time and evolve as you do. You may find you are stuck in a story or belief system you actually don't believe anymore or one that was never even yours to begin with. This is where you have an opportunity to break free from those earlier versions of yourself and those old fear-based beliefs that have been holding you back.

> "He brought them out of darkness, the utter darkness, and broke away their chains." —Psalms 107:14

This is where you get to obliterate the first two reasons I mentioned why people live lives where they are not prioritizing what they value. And as you think about the upcoming prompts and get into this segment of self-discovery, I want you to do the best you can to tap into who you are today, in this moment. Not who you were before, not who you think you should be, not who you think the world thinks you should be.

As you rediscover yourself, you get to redefine your life! How exciting is that?!

The other thing I will ask from you in this section is to think outside the box. Over the years, as I have done this portion of the exercise with people, this is where they typically tend to play small, mostly because many of us feel we don't deserve or aren't worthy of the things we actually value. That is why we end up spending our time on—and *for*—other people, or we stay stuck in a life that suited a past version of ourselves instead of progressing forward into the life we truly long for.

CONNECTING TO YOURSELF AND YOUR VALUES

- ▶ Grab your journal or a sheet of paper.
- ▶ Light a candle, grab a cup of coffee or tea, and get comfortable.
- ▶ Don't rush or try to be perfect.
- ▶ Imagine that there is no box, no right or wrong answers.
- ▶ Take time to answer the following questions (and if some don't resonate, skip them!)
 - What do you like doing?
 - What is fun for you?
 - What experiences do you cherish?
 - What people, opportunities, behaviors do you respect?

- What is something you look forward to doing every day, every week?
- Is there something you are passionate about?
- What are the things you can't see yourself living without?
- Do you enjoy traveling?
 - Where do you like to go?
 - Why?
- Do you have a secret place?
 - Pro-Tip on secret places: I have been encouraging people for years to have a secret place. Maybe this is a cafe where you love to grab a coffee and read a book. Maybe it is a specific spot along the beach. Maybe it is in your bed, with your favorite blanket and phone on Airplane Mode. This is a place you can go, where you feel safe, where you feel like you, that is yours.
- What is important to you regardless of the world around you?
- What are some other things you value?
- What makes you, you?
 - What is something that is considered a "quirk" of yours?
 - Is there anything you do that is your "signature" move, activity, or hobby?

DON'T THINK, WRITE

At first, those questions may be hard to answer. You may find yourself regurgitating canned answers reserved for water cooler conversations. To combat that, try this tip I learned from Gabby Bernstein.

Years ago, I attended several of Gabby's more intimate events where we spent a lot of time journaling and cracking open our hearts and minds to new ways of believing. Before my work with her, I felt small, limited, unworthy of being seen or heard, let alone asking for or going after the desires God had put on my heart.

I vividly remember sitting on the floor at a retreat center in Massachusetts. Dozens of women were in the room with us. Gabby was sitting in front of us, mic in hand, guiding us through a meditation to help us settle into an intent for the day.

As she would prompt us through particular questions, she would remind us to relax and to be honest with ourselves. She would say, gently, "Don't think, write!" knowing that a part of our minds was trying to hijack our innate ability to let our initial thoughts and emotions come through. She knew we were censoring and editing our very own thoughts and feelings as they were on the way out instead of being honest with ourselves.

She would also remind us to be "nonjudgmental observers" of what we were thinking, feeling, and writing, to not doubt what we were writing. This way, we didn't get caught in the trap of having to perform (be the best, go over the top) or compare ourselves to others.

Which brings me to a tip of my own that I'll share to support this one from Gabby, based on what I've witnessed as I've walked others through this:

Do not disqualify anything simply because of current limitations (comparing ourselves / stacking ourselves up against our current situation).

Because, trust me, when we go back and revisit your Current Time Inventory, and you start removing the things you do not enjoy doing, you are going to find you will have plenty of time available to start integrating the things you do value. And if the things you value are not readily available, you will have plenty of time to devise a plan that will get you closer to a life where they are.

ACKNOWLEDGING THE FEAR THAT IS HOLDING YOU BACK

With this new understanding of the significance of what you value and prioritize, I'd also like to touch on something else that is significant: your F.E.A.R.s. Here, I will share with you some factors that have kept people from prioritizing the things they value so you can prevent them from holding you back, too.

F: The first factor is decision *fatigue*. Decision fatigue "is a state of mental overload that can impede a person's ability to continue making decisions."[4] This is especially

significant if you are making an incredible number of decisions in a day and definitely if the decisions are part of a major or traumatic life situation. As you move through this process, it will be important for you to identify the areas of your life or times of day where decision fatigue wreaks havoc and to find ways to minimize its effects on your life.

E: The second factor shows up when things become *easy*, when you become "good at" something. When you have found yourself in a place where the hard work is all done, you've paid your dues, and you're riding the wave. It may be hard for you to justify rocking the boat or changing things, no matter how badly you may want something. The fear of creating change (even for something good) often comes with a fear of uncertainty, and for this reason, many people choose the familiarity of a mundane, easy life where they are "content" over an alternate reality of radical aliveness and ultimate satisfaction that awaits.

A: This factor is complacency. When you approve of your current state simply because it is the way you've *always* done it, whether it is working or not. The interesting thing about this one is that although a person's life may seem calm and easy, that person may not actually be satisfied. In fact, in my experience, many complacent people aren't necessarily happy, and they also have a lot to say about those on the other side of the fence who are ambitious, high-achieving people chasing their dreams.

R: The last factor pertains to *resources*. Everyone has a story in their head about how they don't have *enough* of something that is required for whatever the change in their life may be. You're never going to be ready or feel like you have all the resources you could possibly need—for the change, for the conversation, for the relationship, for the children. There's never going to be enough time, enough money, enough courage.

GETTING CLEAR ABOUT YOUR FEAR

Take a moment to reflect on these fears. Ask yourself the following questions and take some time to journal or think about each answer.

- Which FEARs resonate with you the most?
- When, where, and how does decision fatigue affect your life?
- What situations do you find yourself in where you avoid change because of the fear that it would be too hard to adopt new behaviors?
- In what areas of your life are you ready to step out of your comfort zone?
- In what areas of your life have you become complacent?
- Where are you settling?

- In what areas of your life are you choosing comfort over your dreams?
- What areas of your life are currently easy? Areas where you may not be ready to shake things up or rock the boat?
- In what areas of your life do you consider yourself happy and unhappy?
- In what areas of your life do you feel fulfilled? Unfulfilled?
- What resources in your life would you like to have more of?
- What could you accomplish if you had those resources?
- Why do you not have those resources?
- What is something you could do to obtain them?

Remember, as we continue to discuss the upcoming Facets, we are doing so with the intention of rediscovering ourselves and gaining some clarity around each one. By doing so, we are able to better understand ourselves and what it takes to create our Best Day, Every Day.

We are examining these intimate and unique parts of ourselves that often go unnoticed and unsatisfied so that they may be brought to the forefront of the way we choose to live our lives.

Many of us know the feeling of having our needs unmet, but we don't take the time to understand how to

fulfill them. Working your way through this book will help you to accomplish just that. This way, you will come to understand yourself in a deeper way and know exactly what it takes to experience fulfillment.

CHAPTER SEVEN

THE THIRD FACET

SATISFACTION: THE PLEASURE EXPERIENCED WHEN A NEED IS FULFILLED

As I navigated my "new normal" during the early stages of the pandemic and my divorce, I had a lot of time (maybe too much time) to reflect on and practice my self-awareness. When I was dabbling in the creation of my very first Current Time Inventory, I had very little to report, yet somehow did not have a whole lot of energy to spare. I was lost and hopeless. (Remember the bathtub?) Even though I had made my pact, even though I had invited God in, even though I was aware of the spiritual warfare, even though I was no longer considering myself lukewarm, I was still struggling.

I had created my Current Time Inventory and categorized it. I had a lot of blank space, a lot of opportunity. I knew I had to redeem my time in a new way. I had to do things differently.

Instead of trying to control my time, I began to observe. I became more aware of my good days and my bad days. I was experiencing a variety of emotions, picking up old habits, making poor decisions. Some days, I was motivated, enthusiastic, optimistic. Others, I was defeated and back in the bathtub.

I later realized I was feeling this way because, although I was aiming for my Best Day, Every Day, doing what I could to prioritize the things I valued and found significant, having my dessert before dinner, and facing my FEARs, I was still experiencing stress and worry around my lower-level deficiency needs located at the bottom of Maslow's hierarchy (remember I mentioned these earlier? The D-Needs?) and that I was allowing my circumstances to dictate who I was instead of behaving as though God assigned and positioned me.

These needs are referred to as *deficiency needs* because when they go unmet, they can prevent us from advancing further up the hierarchy. And when we are being motivated by those deficiency needs—things along the lines of, *Where will I sleep? Where will I live? What will I eat? Do I have enough money?*—it is natural for our behaviors to be motivated by the status of those needs and difficult to justify expending energy on things that we may label as *excess, extra, rewards*, or not important or significant enough to allot time for. These are things that would normally fall under the labels of what we value or ways we would show up for ourselves. Think along the lines of, *It would be nice to take a walk; I would love to go

to California; Maybe next month I'll schedule a massage; I wish they would just be nice to me.

According to the most popular parts of Maslow's work, only those people who successfully make it through each level of the hierarchy can operate from a place of self-actualization with regular peak experiences and live life from a place of overflow and abundance.

Although, in his book, *Toward a Psychology of Being*, Maslow shares that, on occasion, the average person can experience *episodes* of self-actualization, moments in time where the person "takes on temporarily many of the characteristics ... found in self-actualizing individuals." He goes on to say that the person "becomes in these episodes more truly himself, more perfectly actualizing his potentialities, closer to the core of his Being."[5]

In the same book, he says the following about peak experiences: "The person in the peak-experience usually feels himself to be at the peak of his powers, using all his capacities at the best and fullest."[6]

He describes a slightly different aspect of fully functioning as effortless and ease of functioning. What takes effort, straining and struggling at other times is now done without any sense of striving, of working or laboring but instead is smooth, easy, effortless and everything "clicks."

He describes the person in peak experiences as someone free of blocks, inhibitions, cautions, fears and doubts, someone who is the most unique and individualistic they could ever be, the most free from the

past and of the future, someone who is "all there" in the current experience.

These were the things I was longing for. These were the feelings I wanted to feel and the experience I wanted to have. But I did not have it in me to take on a major challenge, and I did not want to end up in another Self Help Spiral. I wanted to move forward steadily towards something that would get me closer to the life and the experiences I had been longing for.

I reflected on Maslow's hierarchy and imagined myself at the base of it. I was starting over, entirely. And with the pandemic in full swing, it was safe to say that I was facing some additional obstacles. Climbing this hierarchy seemed daunting, impossible almost.

Thankfully, I had my health. I was in regular therapy, and my mind was getting clearer. I had somewhere to live and was receiving assistance from the state for my groceries and to pay some of my bills. I was still far from operating at a surplus at the base levels of the pyramid, but I was getting by.

But then, I had the thought: What if this pact that I've made with myself and with God, this *commitment* to self-actualization, and the belief that I am worthy enough to *commit to the journey* of self-actualization, this relentless pursuit of my peak potential, is actually all I need to begin experiencing the life of the so-called self-actualized person?

In other words, what if committing to the relentless pursuit of ourselves, the unique person God intends us to be, is the *only* requirement necessary for peak experiences

to take place in our lives? After all, isn't that what we are all actually after? To experience life in the most alive and fulfilling ways possible?

UNDERSTANDING THE DEFICIT SELF AND THE SURPLUS SELF

When we make this commitment, we are also accepting where we currently are, knowing we are perfectly positioned for our next move. Accepting that where we are is where we need to be also places us in a state of gratitude for everything we have, making it *enough*.

This then allows us to be confident in God's plan, which is exceedingly and abundantly more than anything we could ever imagine. And, as a result, we begin to operate from a state of overflow (surplus) instead of from deficiency, also qualifying us to experience what Maslow identified as B-Values—things like wholeness, truth, justice, beauty, and goodness (the qualities associated with the experiences of the self-actualized).

I mention this for two reasons:

1. People are often too busy and too distracted chasing after the wrong things to realize that they are unfulfilled in the areas that really count. They are busy all the time and feel like they are working all the time but do not have systems in place to actually achieve the results they are aiming for—or they have not set clear goals to aim for in the first

place, leaving them unable to have any confidence around whether or not their needs and goals are met, let alone the ability to rest assured knowing that they are set up to experience fulfillment.

For example, you may be stuck in a situation that is keeping you in a place of operating from a deficit and may not realize that with just a few adjustments, you could find yourself thriving in a state of overflow. But because of your current limitations, you remain stuck instead of taking the time to design a new reality and taking the steps forward to actualize it.

2. People have plenty but never feel like they have enough, leaving them feeling empty. Having your needs fulfilled and actually *feeling the feeling* of having your needs fulfilled are two totally different things.

For example, for you, a $100,000 annual salary may be a goal, as it was for me and many people in my circle growing up. But, for some people who are used to earning that much or more in a *month*, that would feel like a terribly insufficient annual salary. So, without being clear about what our exact needs at each level of this hierarchy actually are, it is hard to monitor if and when those needs are fulfilled.

Similarly, having a high income does not equate to fulfillment. Sure, a person's basic, lower-level deficiency needs may be satiated, but money doesn't guarantee emotional, mental, and spiritual health or fulfillment.

Additionally, we have to understand there will be levels of actualization, an unveiling of sorts, that occur as one collapses the distance between where they are now, where they want to be next, and where they want to be ultimately.

We string together closures of liminal space, making progress up the hierarchy in one area of our life, only to find ourselves at the bottom of the same hierarchy in another area of our life. It is safe to say we will forever be working our way through layers and levels of being satisfied, only for new needs at new levels to emerge.

So instead of looking at life as a short-term opportunity to win a race with a definite end, or to climb a mountain by following the same hiking path as everyone else, we can begin to appreciate the fact that not only do we all have the option to find our *own* way, but it would be better if we *actually would*.

In fact, Maslow said, "A musician must make music, an artist must paint, a poet must write, if he is to be ultimately at peace with himself. What a man can be, he must be. This need we may call self-actualization ... It refers to a man's desire for self-fulfillment, namely to the tendency for him to become actually in what he is potentially: to become everything that one is capable of becoming ..."[7]

Additionally, he's urged us to remember that "each man's task is to become the best 'himself'"[8] that we must

not try to be like others. That we must become the best person we can be, the best version of ourselves. So, my only job is to become the best Rebecca Corvin that there is, the best Rebecca Corvin in the world. Maslow says this we can do, and *only this* is necessary or possible. And this is also where we have no competition.

What a relief is that?!

The only job or goal we actually have is to be the best version of ourselves that we can be.

To realize that the journey of life is not a competition, does not have to be full of hustle and comparison, but could actually be a leisurely hike where we can risk being seen in all of our glory and risk seeing others in all of theirs.

So when we begin to reclaim the way we are living our lives, to concentrate on fulfillment through these Facets, and make the choice to redeem our time instead of spending it, we really are making a commitment to leveraging exactly where we are as the perfect foundation for where we will go next. And in accepting our past circumstances, we are accepting that we are where we should be, which means we are also accepting who we have become, as we are on the way to who we will be.

In other words, we are reclaiming our current situation as *enough*, for now, while we get a plan in place to pursue what's next.

MOVING FROM THE DEFICIT SELF TO THE SURPLUS SELF

Moving forward, keep the journey from the Deficit Self to the Surplus Self in mind. In order to experience the progress you are seeking, you must be able to identify where you are currently, including your areas for improvement, so that you can create opportunities to close those gaps.

- ▶ Refer back to Maslow's hierarchy in Chapter Three. Without overthinking, in which areas would you say you are currently deficient?
- ▶ What are the D-Needs that keep pulling you down from experiencing fulfillment?
- ▶ If you were hypothetically climbing the hierarchy, where would you place yourself currently, and why?
- ▶ Do you believe in the realization I had come to believe? That committing to the relentless pursuit of ourselves, the unique person God intends us to be, is the only requirement necessary for peak experiences to take place in our lives? If yes, GREAT! If not (yet), take some time to write about why.

MASLOW'S NEEDS IN MOTION

Although I am convinced we can have episodes of peak experiences without "climbing the hierarchy," when we look at Maslow's hierarchy, we see that it consists of

things that all humans truly do need. By no means am I recommending that you ignore them. I am recommending to not get so caught up in them that it prevents you from being present and alive in your experience.

Instead, get familiar with the needs and how they apply to your life. Use this section to let your mind wander a little and play with ideas that allow you to rest assured that you are actually fulfilling your needs versus simply checking a box. I will share with you some of the things I believe are most important when it comes to satisfying these human needs, giving you examples of tangible things to implement in your life as well as some things to consider.

I refer to the following as ways to put Maslow's Needs in Motion, and it is my belief that if we are well acquainted with the way we relate to each of the areas and have a sound plan to be satisfied in these areas, we will have a solid foundation with needs that are met which will allow for the opportunity to have peak experiences regularly. As you review the following, I challenge you to utilize the lens of your Surplus Self, the one that sets yourself up for experiencing self-actualization, expecting peak experiences, and deploying the B-Values.

SLEEP

Physiological Need.

Other examples according to Maslow include breathing, food, water, shelter, and clothing.

Now, you might be thinking, *Oh my gosh, she's about to tell me I need to sleep eight to ten hours a night. Or, I need to wake up early and go to bed early.* Don't hold your breath. None of that is about to happen.

What I will say is that sleep is important. All humans need sleep. Without getting too detailed, we can all agree that adequate sleep is crucial for physical health and function. Without proper rest, the body cannot operate optimally. It will be extremely important that you uncover how to personally define proper rest based on your needs.

You must become aware of the sleep experience that works best for you. Some of us are morning people; some of us are night owls. Either way, it's perfectly fine—there's no right or wrong answer, as far as I'm concerned. I'm not here to tell you which one is correct.

On your best day, how many hours of sleep did you get the night *before*? On your best seven days strung together that were just *immaculate*, how many hours of sleep were you regularly getting in that ideal circumstance?

Although it is important to determine how many hours of sleep you need, I would also like to challenge you to consider your entire sleep experience. For example, something that has changed my life is to go to bed before I'm tired. I don't know where it came from, and I don't know when I started doing it, but instead of taking myself to bed exhausted, on my best days I take myself to bed before I'm tired.

I also like to fall asleep to some kind of binaural beat or sleep playlist—some kind of noise—and I like to wake up to an alarm. I like to sleep in certain clothes, and I have become particular about my bedding.

As we consider how to put this need in motion in your life, consider not just the act of sleeping but everything around your sleep experience. And then on your ideal days, on your best days, these days that are designed by your Surplus Self, we want to design to happen repeatedly, what does that sleep experience look like?

Some things to consider:

- ▶ What does your current sleep routine look like?
- ▶ What time would you like to be asleep each night?
- ▶ What things would you like to do each evening before bed? (Examples: shower, bath, read, pray, journal, set diffusers, watch a television show, go for a walk, have a cup of tea or particular snack, etc.)
- ▶ Based on the time you'd like to be asleep, what time do you need to begin to prepare for bed so that you can include all of the things that will make up your routine?
- ▶ What needs to be in your bedroom? (Examples: I personally enjoy plants in my bedroom. I am a fan of room darkening/thermal curtains and one or two essential oil diffusers. I also keep several (uplifting) books on the nightstand so that I can choose to read from something different if I'd like to each night. I also have an Alexa echo speaker (that sounds really great) for listening to binaural beats or a sleep playlist.)

- What needs to be removed from y
 (Examples: I haven't had a televisi
 in quite some time. When I travel,
 like a treat to watch television from bed. I've also
 always made sure to never bring work into my
 bedroom. At one point, I had a desk in my bedroom
 but chose to remove it and now, I rarely even take
 my laptop or phone into bed. Many people prefer
 to keep all electronics out of their night routines to
 help wind down and prevent distraction.)
- What is your favorite blanket or pillow?
- What is your preferred set of sheets or pajamas?
- Do you like to make your bed?
- What time would you like to wake up each morning?
- Do you prefer waking to an alarm or naturally?
- What would you like the first three things that you do when you wake up to be?
- How can you set yourself up so that those things happen?
- What are some of the things that get in the way of your ideal sleep routine?
- What can you do to make your ideal sleep routine sustainable?

MOVEMENT/PHYSICAL FITNESS

Physiological Need.

Other examples according to Maslow include breathing, food, water, shelter, and clothing.

Regular physical activity is essential for maintaining good health and bodily function. I also believe that it is critical to *feel*, to understand how to get out of your head and into your body, and to be familiar with the activities that ground you.

I intentionally use the word movement here because I want to make it clear that when I say movement, I am not specifically referring to exercise or working out. To be honest, up until the past year or so, I haven't even been a really big fan of this word; thinking about making time for the gym or lifting weights was a major trigger for me.

As a new mother struggling with anxiety and navigating postpartum, it was hard for me to ever justify spending time on myself. I never seemed to have the energy, anyway. There was always an internal struggle going on where part of me wanted to pour into myself and make time for moving my body, but the reality was that I didn't have the time, the mental capacity or the strength. I now know how important it is for our bodies; I just wish that someone would have encouraged me to make it easy and to explain the connection between our minds, hearts, and bodies sooner.

So when I say movement, I'm talking about moving our bodies in whatever way that helps us feel good.

Whatever this looks like for you is the best choice. It could be dancing, going for a run or a walk, or hitting the gym. This work you're doing is for you, so ask yourself: What do you require on a daily or weekly basis that makes you feel good? Regardless of how you land here, I just suggest that it be something you are intentional about.

Then consider how you can weave this activity into your day or week so it makes the most sense for you in this moment. For years, I was a really big fan of Beachbody, a fitness program that offers a variety of home workout videos aimed at helping people achieve their fitness goals. Because of the convenience and timed workouts, it was what I could most easily fit into my schedule. Last year, I worked one-on-one with a personal trainer at the gym a couple of times a week and integrated what I learned as I began working out on my own and in hotel gyms as I traveled.

Trust me, that had not ever really been who I was. For *many* years, there was very limited movement. Deliberate exercise or working out in my life outside of being a mom just didn't exist. But as I changed and evolved, as my situation changed and evolved, I was able to realign my values with my physical health being one of my top priorities. Working with a trainer was an investment I was willing to make (both financially and with my time), and it has set me up for consistency and capability when I am in the gym on my own.

As you're considering what your nonnegotiables and preferences are under this section, understand that, to start, it could be as simple as going to the park with your kids, and instead of sitting on the bench, you stand the

whole time. Lean on technology like fitness watches and apps to help encourage you and track your steps.

Ultimately, you must be realistic—don't let this section overwhelm you. Movement is something that can make people feel anxiety-ridden, but it doesn't have to be that way. Simply ask yourself, on your most ideal week, what does movement look like for you?

Some things to consider:

- ▶ What is your current relationship with movement and physical fitness?
- ▶ In what ways do you currently excel when it comes to your movement and physical fitness?
- ▶ In what ways do you struggle?
- ▶ When you think of moving your body, what is most appealing to you?
- ▶ How many times each week would you like to move your body in this way?
- ▶ What kinds of things can you do that will assist you in moving your body?
- ▶ Outline what a realistic week of movement could look like for you. (Example: 20-minute walk outside 3 days each week plus 2 days in the gym.)
- ▶ Does it make sense for you to get a gym membership? Join a spin class? Start dancing?
- ▶ Who can be your accountability partner and cheerleader?

- ► Is a fitness coach or personal trainer something you think you're ready for or need?
- ► What can you do to set yourself up for success in this area?
- ► How can you set yourself up for consistency versus perfection?
- ► Do you need to create a workout routine or schedule?
- ► What kind of things motivate you to move your body?
- ► When you're at the gym, walking, or exercising, do you listen to music? What kind of music do you prefer? Have you made a playlist?
- ► What clothing makes you feel most comfortable when you are working out?
- ► Do you have a preference for a specific protein shake, juice, or snack pre- and post-workout?
- ► What time of day do you prefer to work out?

FINANCES

Safety Need.

Other examples according to Maslow include employment, personal security, and resources.

Although this may be an uncomfortable conversation for some, the reality is, our financial situation plays a crucial

role in what our lives look like, how we feel, how much pressure we place on ourselves, and how much time we devote to particular things. Having a healthy relationship with money can provide you with mental, emotional, and time freedom. I wish I would have learned this way sooner.

I have spent all of my life in a very small town in southwestern Pennsylvania. It seems that almost every conversation I have with someone I know, or do not know, has been hinged on money. Standing at the gas pump, "Can you believe these prices?" Overhearing someone at a restaurant, "This guy doesn't deserve a tip." In college, "It takes money to make money."

When I tell you that I have had to do a tremendous amount of brain rewiring when it comes to this topic, I am not kidding. I don't even know if Derek Shepherd could handle this amount of energetic neurosurgery.

I have absolutely spent more time, more money, more brain power, and more of other peoples' brainpower on this topic alone trying to understand the mechanics of why some people have money and others do not. Additionally, I have become fascinated with the way some people equate having a particular amount of money to success while others define success entirely differently. And I've learned a lot.

I have learned that we all have some kind of goals around money. They may not be clear, they may not be in spreadsheets, and it may not be the same number all the time, but we do have them.

I have learned that many people are afraid of their financial situations. They are afraid to know just how

far in debt they are, just how much their monthly living expenses actually are, just how much they spend at Target.

I have learned that there is not just fear, but terror, around earning, handling, and being responsible for certain amounts of money and assets that are valued at certain amounts of money.

I have learned that habits around money are inherited, can sometimes be contagious, and can be directed in ways that could have either a positive or negative result.

I suggest we take those goals, those numbers, out of our heads and put them into spreadsheets, our journals, on Post-it Notes. That we take the fear out of our financial situations and (just like our Time Inventory) get real about where we currently are versus where we would like to be and then get clear about what we actually believe about money and why.

There is no magic financial number that will fulfill you. Money is a tool. Money is a vehicle to assist us in living a fulfilled life. But, as I mentioned earlier, money is not the thing that guarantees peak experiences; your commitment to this pursuit is.

Although your fulfillment is not contingent solely on your financial situation, I can almost guarantee that the moment you get a handle on it and get a plan in place for your future, you will eliminate a lot of the clamor and stress around this particular part of your life that can be freed up for something more important.

Take a little bit of time here to think about your ideal financial situation. Do not overwhelm yourself. Using some vague numbers and what you can recall off the top of your

head, sketch out your estimated income and expenses. Ultimately, just as with the Time Inventory, you'll want to account for all of the money that comes in and out of your life currently so that you can course correct towards a scenario where things are curated according to what you actually want and need.

When it comes to your finances, I recommend an approach that is similar to the Time Inventory Tool we completed in Chapter Five.

Step 1: Financial Inventory Tool

- ▶ Grab your journal, sheet of paper, or open a new spreadsheet.
- ▶ Document all of your open accounts, including balances.
 - Checking accounts
 - Savings accounts
 - Investment accounts
 - Credit cards

Do not over-complicate this or let your fear get in the way of looking at this information.

The pivotal questions here are:

What accounts do you have?

What are the balances in each of the accounts?

What accounts do you use?

What accounts could be closed or consolidated?

Step 2: Line by Line, In and Out

- ▶ Pull statements for each of your accounts.
- ▶ Review them, line by line to get an understanding of what is going in and out of each account.
- ▶ Note the changes that need to be made.
 - Do subscriptions need to be canceled? Downgraded?
 - Should automated payments be coming out of a different account?
 - Can automated payments be set up for your recurring payments?
 - Utilities
 - Vehicle
 - Mortgage/Rent

Step 3: Assets & Future

- ▶ Here is where you make a list of all of your assets.
 - Home, vehicles, property, investments.
- ▶ Or make a plan for the assets you'd like to have.
- ▶ This is also where I suggest consulting with the kinds of advisors you need to, in order to get some momentum under the goals that you have after taking inventory of your current financial situation.
 - Debt consolidators
 - Lenders for a home
 - Real estate agent for potential properties

- Consultants for life insurance, brokerage accounts
- Rolling over old 401 (k) accounts
- Opening accounts for children

Keep in mind, this does not all have to be done in one sitting, especially if this is the first time you are doing an audit of your finances like this. Sorting through our financial situation can be overwhelming and seem daunting.

I would suggest that you break this up into separate sessions and make it as easy as possible for yourself. Also, keep all of your information somewhere that makes it easy for you to navigate logging in and out of your accounts and accessing the information you need. Sometimes, the most stressful part is hunting down passwords and checkbooks. Work smarter, not harder, here. Gathering this information is simply that—gathering information. Try not to be over critical or judgmental of yourself, just gather the data. We will work on what to do with it later.

FAMILY & FRIENDSHIPS

Love and Belonging Need.

Other examples according to Maslow include friendship, intimacy, and connection.

I'm not sure which can be more difficult, discussing finances or discussing family. In my experience in the

world of personal development, I've realized that many people who seek help through therapy, mentorship, coaching, or even books like this one do so because they cannot share this aspect of their lives with family members. Usually this is because their family members are not on the same personal development journey, they simply do not understand it, or the behaviors and actions of family members have contributed to the reasons to explore new parts of ourselves in the first place.

I think it is important that we let our family be our family and to not place any unnecessary pressure or expectations on those closest to us. What is peculiar about this, though, is that many of us long for support from our family members the most, and yet, we don't receive it or know how to obtain it.

For the sake of focusing on family as a Facet of Fulfillment, realize that family can have a broad and flexible definition. Ultimately, the people who fall under this category of family should be those who love you unconditionally and consistently, regardless of your flaws. Taking it a step further, we can also consider "whoever does God's will" as our family.

> "Then he looked at those seated in a circle around him and said, 'Here are my mother and my brothers! Whoever does God's will is my brother and sister and mother.'" —Mark 3:34-35

The Village Factor

For many years, I facilitated meetings in my hometown that we endearingly referred to as Village Meetings. These meetings were mostly in-person and consisted of an opening exercise that grounded all of us into the meeting (a meditation or prayer), was sometimes followed by a lesson or bit of teaching I would share, and then it was an open forum for guests to share whatever it was that was on their hearts. We would laugh; we would cry. But we wouldn't apologize for any of it. The Village was the place where we listened and learned, the place many of us didn't even know we needed.

After witnessing the transformations people were having once they had attended several meetings, I had to come up with some way to explain what was happening. I called it The Village Factor. The Village Factor is the variable that promotes growth and transformation in an individual when he or she is seen, heard, and feels a sense of belonging to a group.

Another way to describe it would be as the potential that is actualized as a result of the support from and connection to a group. The results that these people were having, simply by being seen and heard (as they were) were remarkable. There were people who were coming off their anxiety and depression medications, making their doctors curious about what had changed. Others were leaving their jobs or unhealthy relationships. Still others were taking better care of themselves and their children.

Some were getting married, or getting pregnant. Because they had a sense of connection, a sense of

belonging, this need of being held and loved was satisfied, giving them the confidence to do whatever it was they knew they needed or wanted to do, to risk being seen in all of their glory, even outside of the meetings.

Curating a Support System

Your support system doesn't have to be an actual group of people that meets regularly, and it doesn't have to be your blood-related family. In fact, I like to lean most on what I refer to as my Curated Support System. A Curated Support System is one you develop based on your needs, and the interesting part is that it could be made up of people you actually don't even know.

What I have found is that different people unlock different aspects of others, that when we are looking for someone to support us, we are oftentimes really looking for someone to remind us of who we are and what we have set out to do.

Most likely, as you begin to curate your support system, you'll think of your close friends. I'd like to challenge you to be mindful when doing so. Just because someone is close to you, doesn't mean they are capable of holding space for you, giving you advice, or supporting you as needed.

I had the opportunity to learn this lesson early because God gave me the best girlfriend anyone could ever ask for when I was in the second grade. Since then, my dearest and longest friend, Kaitlen, has been the example of what I am referring to here. She is selfless, objective, and empathetic. Even as our lives changed and our paths went in different

directions, we still remained close, we still checked in on each other, and we were still one another's first call when a crisis arose.

It doesn't matter what is happening, where we are, or what we are doing, when I need her, she is there. Period. Whether it was a breakup in high school, fights with our parents, crying in bathroom stalls, or wrestling with the consequences of our own poor decision-making, we've been through it, together. My favorite part of our friendship has been the closeness we're experiencing now, now that I'm observing her live the life she dreamed about and went through so much for, the one where she is an incredible mother. Find your Kaitlen and hold on tight.

As you create your first Curated Support System, it may consist of friends you can meet for coffee or lunch, mentors you can call as needed, or people who inspire you that you haven't met yet. It'll be important to have a running go-to list for this Curated Support System because sometimes, you'll need to vent, talk and receive feedback from your friends and mentors, but other times, you may simply need to be in the energy of people you find to be great and just listen.

Some things to consider:

- ► Which people and places in your life make you feel the most loved and accepted? Why?
- ► Which people and places do not? Why?
- ► Is there a way for you to redeem more of your time with those who truly bring you a sense of belonging versus spending time with those who do not?

- If you were to create your own Curated Support System, what are some names that come to mind immediately?
- Who are three people that inspire you? List them along with specifically why they inspire you.
- What can you do to easily connect with these people?
- Could you dedicate time in your schedule for these people and places? If so, when? How frequently?
- In what ways can you nurture these relationships?
- How can you bring value to the relationships that help you feel the most valued?
- Would it be feasible to schedule recurring meetings with these people? Visits to these places?
- Is there anyone that you need to talk to in your life about something important? What is keeping you from talking to them? What would you say?
- Who do you need to forgive?
- What conversations have you been avoiding?
- Are you at peace with the way the relationships with your friends and family currently stand in your life?
- Do your friends and family know that you love them? How?
- Where can you go that just feels like home? Why?

MOTIVATION

Esteem/Self-Actualization Need.

Other examples according to Maslow include respect, confidence, and experiencing purpose.

A high-level sense of motivation is the driver for the bigger picture. It is the thing that gets you amped up and excited to take action. Realizing what motivates you and why will give you something to lean on when you start to get tired in the valleys.

Motivation is so important! If you struggle with discipline like I do sometimes, motivation is what you need. You need to know where to go to get your motivation because it's not always going to come easily. You're not always going to be in a manic phase of wanting to do everything and be everything, right?

I think it's really important that we have something that motivates us, and what uniquely motivates you could be so many different things.

For me, it's YouTube videos or podcasts of people I admire sharing their stories, or of people who have done the things I want to do and make it look and feel super realistic for me. It's people who are hyping me up and reminding me: *You can do this! You're worthy of this! You deserve this!*

I love hearing success stories, learning about the backstory of somebody's life and what got them to where they are. That kind of stuff hypes me up. It also hypes me

up to have mentors who help get me in whatever vibe it is I want to be in. Even if I'm not in the moment feeling incredibly successful, great, or motivated, I know there are people in my life who carry that energy that I can lean on.

I've been following Steve Harvey for years. So many people know him from a comedic standpoint, but he is absolutely incredible! He has changed my life in many ways, and for his continued effort I am so grateful. I hope one day I get to personally look him in the eye and shake his hand and thank him for who he is. I've never completed watching one of his YouTube videos or hearing him speak without feeling super hyped up and motivated. The same thing goes for Jim Carrey, as I mentioned in Chapter Two.

Amanda Frances is somebody else I have consistently followed for years. I love her very specific vibe, her faith—everything about the way I perceive her is confident and unapologetic. There's also Dr. Wayne Dyer, Steven Furtick, and Lewis Howes, among others.

The point here is to get clear about who or what motivates you. It has taken me years to let myself settle into the idea of leaning on others for support when I need it, but now that I have, I have no shame in directing my attention to a particular sermon, meditation, or motivational speech that I know will anchor me back into my truth each and every time.

Some things to consider:

- ► If you have an ideal week of seven perfect days strung together, what motivated you the most throughout that week?

- On your best weeks, what keeps you afloat, or what brings you out of that darker, heavier place?
- Whenever you're feeling like you need that little bit of a lift, what is it that motivates you?
- Name three people you actually know, who you can pick up the phone and call, who motivate you.
- Name three people you look up to or admire, that maybe you've never met, who motivate you. What about them makes you feel motivated?
- What deficiency-need (D-Need), according to Maslow's Hierarchy of Needs, would you say is currently your biggest motivator (physiological, safety, love and belonging, self-esteem, self-actualization)?
- If there is someone in your life you are working hard for, who is it? Why?
- Are you connected to a vision that is larger than you, that is motivating you to keep going? What is it?
- Why have you not given up yet?

LAUGHTER

Self-Actualization Need.

Other examples according to Maslow include creativity, experiencing purpose, and meaning.

I remember back in 2020, in the early parts of my separation (and the pandemic), I found myself up late one night staring at the television but not actually watching it. People on the screen were dancing, laughing, embracing. I remember thinking that it was so phony. That life wasn't actually like that. People didn't actually behave that way. I was somehow struck with some self-awareness the size of a mustard seed, and I caught myself in my resentment, my envy, my hopelessness. I thought to myself, *Becca, when was the last time you laughed?*

I remember getting up from the recliner, finding my phone, and going into the bedroom. I was on a mission to find something, someone to make me laugh. I went online and searched for hours, swiping through comedians like I was on a bad dating app, until I came across a man named Trey Kennedy and his "Girls during fall be like …" video that sent me down a rabbit hole of his years of skits where he is, according to his YouTube bio, "basically just really extra."

> "Because of the littleness of your faith; for truly I say to you, if you have faith the size of a mustard seed, you will say to this mountain, 'Move from here to there,' and it will move; and nothing will be impossible to you."—Matthew 17:20

It was exactly what I needed. Light-hearted, relatable comedy that reminded me of the fun and joy that could be experienced in life. And most importantly, finding Trey's comedy reminded me of something that I had forgotten—people like him exist. And not just faraway on social media

somewhere, but in my life. I have friends who are funny. I am funny (at least I like to think so!) It was as if an entire vortex in my life reopened, one where I realized I had been stuck in a funk for so long that I had forgotten how much fun I used to have. Long before my separation, I had been consumed by postpartum anxiety and depression that totally handicapped my ability to enjoy much of anything. Not anymore.

I now know that laughter is *such* a large part of me. I also believe that all emotion will move through us, regardless of whether it is through crying, lashing out, or laughter, among others. If I can choose, it will be laughter every time (unless I just really need a good cry!) When we release and laugh, it is healing in so many different ways. It helps us to move energy and emotion through and out of the body. I am convinced that we cannot be simultaneously angry, upset, anxious, or depressed *and* laughing. Understand that laughter brings us all the way into the present moment and is joy in action. When we laugh, we release energy, enhance our relationships, and fill our bodies with love, which drives out the fear.

I have some pretty funny friends in my life. I work with a lot of really funny people. I'm blessed to have these jokers in my life that I can call and know they can help me out a little. In the event that I'm so far gone on a bad day that calling them would be out of the ordinary, that's when I lean on people like Trey Kennedy. Since my original encounter with his content, I've had the opportunity to see him live, twice, and meet him. I'm not sure if he would remember, but I thanked him for showing up in a way that helped to

pull me (and I'm sure many, many others) out of some dark places. I'm just really grateful that there are people like him who bring wholesome laughter to the world.

We need laughter like we need light. We have to remember that as we are rediscovering ourselves—we're putting tools in our tool belt, so each of these needs, including the need for laughter, should be looked at and thought about. We need to rediscover the things that make us laugh, that bring us joy.

Some things to consider:

- ► Think about what the things are that make you laugh. What is funny to you?
- ► What is your go-to comedy movie?
- ► Who is your go-to comedian?
- ► When you need to laugh, who are you calling?
- ► When you need to laugh, what are you watching on television or online?
- ► When was the last time you really laughed? What happened?
- ► Are you subconsciously keeping yourself from having fun? Why?
- ► Revisit a moment in your life that was incredibly funny. Does it still make you laugh today?

CHAPTER EIGHT

THE FOURTH FACET

SENSES: INTELLIGENCE THROUGH WHICH WE INTERPRET OUR HUMAN EXPERIENCE

It is so important for us to rediscover how we operate. Moving from the Deficit Self to the Surplus Self takes time, but it can also be really fun and invigorating. Sorting through the things we find Significant, as well as the things that provide Satisfaction in our lives helps us to get beneath the surface of who we really are, and why. Next, we will take a look at the way we interpret our human experience and consider the ways our senses affect our lives and who we have become, as well as how to lean into them so that we can relish in the simple moments of our day-to-day lives.

Growing up, we learned about the five senses. Some argue now that the human experience is made up of many more senses, maybe even dozens of them! But for the purposes of this book, we are going to focus on the familiar five: hearing, sight, smell, taste, and touch.

As we are rediscovering who we are, exploring each one of these Facets of Fulfillment, in this case, our senses, we are getting to know different aspects of ourselves. What better way to gauge what we enjoy than taking a look at some of the things that satisfy us through our senses?

After all, this journey is about the relentless pursuit of ourselves, and each of us experience things differently. We have different preferences, different likes and dislikes, and many of them are analyzed and decided on by the way they please (or don't please) our senses.

It is my belief that, through our senses, we are ultimately able to relish in the joys of the human experience. It is in these moments, made up of the smell of freshly brewed coffee, deep red roses with soft petals, cashmere sweaters and weighted blankets, cold airy cheesecake, and bright blue skies with fiery sunsets, that we can be radically alive.

RADICALLY ALIVE

In February 2023, I went to a group workshop in Austin, Texas, to work with Somatic Practitioners Angela Ai and David Sutcliffe, who were trained through the Radical Aliveness Institute of Southern California.

Somatic therapy focuses on the mind, body, and emotional connection, most often involving movement of the body (dance, specific trauma-release techniques, and stretches), releasing sound from the body (screaming, singing), or physical contact between two people or a person and an object (think kickboxing or punching a

pillow). Somatic therapy was not necessarily foreign to me, but I had never spent an entire weekend devoted to the study and practice of it and this workshop was exactly that.

Angela and David mentioned the term *radically alive* many times during our weekend together. We spent time learning about somatic therapy, connecting with the group, and supporting each other through each of our experiences.

Of all of the in-person workshops and events I have ever experienced, I'll have to admit that this, by far, was the most transformational, and I didn't realize it totally until the workshop had ended, and I found myself experiencing what I can only explain as a recalibration. It was like someone unplugged me and plugged me back in. Like someone had hit Ctrl+Alt+Del, shut down all existing tasks, and set me into a reboot.

Going through my process in this workshop gave me a chance to come into relationship with parts of me that I had shoved down and hidden from the world. Parts of me that I was ashamed of. Parts of me that had been dormant or turned off for many years.

As flawed and imperfect as I know I still am, I left that workshop feeling more whole than I had ever felt in my life. With more parts of me activated and accepted, more parts of me awake and alive, all of my senses and my entire experience heightened. And through that wholeness and acceptance, I was able to begin to experience life more fully.

It is my hope that, as we sort through the ways your life can be affected by the way you perceive your experience through the senses, you will be able to take steps towards a life that allows you, too, to feel radically alive.

HEARING

There have been countless studies on the origin and ultimate function of music in our lives. I am a firm believer that music is an incredible asset in life and can be used as a psychological vehicle to intentionally shift our mood and transport us across space and time.

It is also my personal favorite go-to when I need an energy shift. It's the first thing I use to adjust if I notice myself having a not-so-ideal day.

I don't think I have to explain to anyone how powerful of a tool music is. Not only can it be nostalgic and motivational, but it can literally encourage us to *feel* things. Music has the ability to change the way we experience our lives, and because of that, I listen to all kinds of music, depending on my mood and what I'm doing.

> "I will pray with my spirit, but I will also pray with my understanding; I will sing with my spirit, but I will also sing with my understanding."
> —1 Corinthians 14:15

In the early stages of rediscovering myself, I realized if I wanted to cry, get my body moving, work out, go for a power walk, journal, worship, or rock out in the car, I had specific artists and genres of music I would turn to.

Your task is to determine which music makes you feel certain ways so that you can curate fulfilling experiences and have something readily available to shift your energy as needed.

Keep in mind that if you're listening to a lot of negativity, heaviness, or darkness, you're inviting those kinds of things in. Remember to be vigilant. Keep it light and happy. Keep it in a place where it romanticizes your life, allows you to feel nostalgia, empowerment, and connection.

Be mindful about what it is you're listening to and how often you're listening to it. Don't forget how powerful these things are. This also applies to the messages you're hearing from the people around you. And your own internal self-talk. Sometimes we need to hear things, and it is healthy; other times, we need to know when to tune things out.

It is up to each of us to monitor and maintain what we listen to, even if that means we have to walk out of a room or schedule time on our calendars to go for a walk and listen to nothing other than what my sweet friend Gianna refers to as nature's wind chimes, the sound you hear when the wind blows through the trees.

SIGHT

There was a time in my career when I would travel often to West Texas for short periods of time. It was flat; the sky seemed bigger than back home; the sunsets were outrageous, and I don't think I ever saw one plant that I would consider a tree.

I remember coming home, back to Pennsylvania, after being there for several weeks. I was driving my normal route to and from a client's office when I realized I had

been in awe for miles. We were on the cusp of fall, and every single color seemed significantly more vibrant than I had remembered. It was as if I was seeing the trees, the grass, the changing leaves all for the first time.

My eyes literally had to adjust to the beauty. It was the same way when I had the opportunity to travel to a small town in Alaska recently, where I had to adjust my reality to the size of the mountains and the turquoise color of the Kenai River.

Unfortunately, many of us are too distracted to witness the beauty that surrounds us. Or, we are seeing too much. We are overstimulated and desensitized to the point that we aren't even sure what we are looking at, what we are seeing, or how we actually feel about the things we have observed.

And I'm not just referring to what we are observing visually, but to see, as in to understand, to perceive, to really grasp what it is that we are witnessing or experiencing. For example, not only can we see the variety of colors in nature, but we can see through someone's white lie that they are doing or feeling okay when we know that they aren't. We have the ability to see when a situation is no longer good for us, to see past our pain, to see someone's heart and intention.

What a blessing it is to see both physically and spiritually, a blessing that many of us take for granted.

As we tap into the way our sense of sight affects us and enriches our lives, we have to ask ourselves how often we are really looking. How often are we really present enough to experience what is in front of us? When was the last time

something caught your eye? The last time you were moved to tears because of something's magnificence or beauty? How often do you intentionally slow down to sit and take it in? To really see where someone is coming from? To bear witness to the grace? The provision? The guidance? This awareness is essential and without it, you will lose sight of what you have set out to do.

SMELL

A loved one's perfume or cologne. Opening an old, dusty book. Fresh-cut grass. Stepping outside when you're blocks away from the beach. Play-Doh. Like music, catching a whiff of any one of these things can take us out of our current experience into another time and place. And as much as I love reminiscing and being nostalgic, I'd like to encourage you to utilize your sense of smell as a means to connect totally with your present moment or as a catalyst for a particular reality or behavior versus only as a vehicle to take you back.

When I was a teenager working in retail, I would park my car in the lot behind the mall and enter through the Macy's entrance. I barely had any money and was living on my own, working while I attended school. In order to get to the store I worked in, I had to exit Macy's through their cosmetics and perfume department—bright lights, mirrors, lipsticks, and makeup artists.

Every day, on my way through, I'd stop at the Chanel counter and admire the display, full of carefully and gorgeously designed bottles of perfume nestled neatly into

custom boxes with luxury labels—gorgeously designed bottles of perfume I couldn't afford. Luckily, I didn't have to. I'd roll up my sleeves and apply a spritz to my left wrist and then my right. I'd set the bottle down, rub my wrists together, pick the bottle back up, and add a little spray to my neck.

I remember walking out of Macy's, into work, feeling fancy and confident, infused with notes of ylang-ylang, neroli, and bergamot, among others. Today, when I spray the only perfume I wear (Chanel No. 5), I'm reminded of the girl who wished she could afford it, and this timeless, luxury scent reminds me not just of where I'm going but where I came from.

There are many ways we can relax into our experience by utilizing different scents. Most popular are candles, essential oils, flowers, and herbs. I would advise choosing things that are wholesome and natural versus synthetic fragrances or options that can affect us negatively or be harmful to young children or pets.

The focus here is to be aware of the infinite ways you can lean on your sense of smell and identify ways you can better leverage that sense to curate a better experience, whatever that experience may be.

TASTE

Not everyone has a good relationship with food, but my hope here is to turn that around. Over the past few years, my relationship with food has pivoted for the better. Preparing meals once seemed daunting, overwhelming,

and difficult. Now, it is simple, and I (can't believe I'm going to say this) actually enjoy it, a little, maybe.

One of the biggest things holding me back from leveraging my sense of taste to have an enjoyable experience was the massive amount of decision fatigue around it. *What do I eat? Where do I buy it? How do I cook it? How much of it do I need? Is there a recipe? Is it healthy? Am I going to have time to make it? Will the kids eat it?* The questions went on and on.

For a while, it was much easier for me to order takeout, or for me to cook something for the kids and eat whatever was left over. Neither of those options was healthy or sustainable. Even when I travel, I now prefer to cook my own food, unless I'm in proximity to the only place I look forward to exchanging calories and carbs for pasta (The Eleven, in Williston, ND) or somewhere you go for the experience like Bohemian (RIP) or The Burger Joint in New York.

Take some time in this section to examine your experience with food—not just the food itself, but the planning, purchasing, and preparing of it. Consider the people who surround your experiences with food. Think about Sunday dinners, holidays, and regular family meals (if you have them, or want to begin having them).

Focus on what you enjoy eating on a regular basis for your regular meals versus what you like to have for specialty meals with friends and family or on days when you have more time or want to treat yourself. Consider what your favorite desserts and restaurants are and how and why you feel the way you do when you get to enjoy them.

Focus on what you can do to remove the negative connotations, stress, and decision fatigue from your experience with food so that you can experience progress in a positive direction and enjoy this part of your life again.

TOUCH

Something about becoming a mother has given me a heightened awareness and sense of touch. All the small, soft clothes. The crocheted baby blankets. The fuzzy stuffed animals. Running my fingers through my children's hair. Gently caressing their noses and cheeks. Then there's the slime, the kinetic sand, the paint, and the LEGOs. The glue, the construction paper, and the yarn.

Children are the best examples of exploring life through their senses, and I have learned more about the ways I can soothe myself, relax, and live by becoming more aware of mine. And it is not only about realizing what pillowcases (silk) and pajamas (silk) we prefer but it is also about long hugs, lying next to each other, walking closely, and holding hands.

As a mother who breastfed two children, I became what is referred to as "touched out" before my children were even a year old. Between breastfeeding, co-sleeping, and baby-wearing, there was rarely any time in a twenty-four-hour period when I was not being touched. This is a common feeling in postpartum women and represents a time in our lives that we later reflect on once our children no longer want the hugs and kisses.

On the other hand, we have a scenario like what happened during the pandemic: touch deprivation. Virtual meetings. Six feet of separation. No handshaking. No hugs. Many studies showed that this prolonged touch deprivation had psychological effects contributing to feelings of isolation and loneliness.

In short, each of us needs touch in our own ways. As humans, we connect and feel safe through certain forms of touch and what we feel through contact with our skin. Maybe it is a weighted blanket, a hot bath, a massage, or a furry robe. Maybe it is a long hug from a dear friend. Maybe it is a gentle pat on the back or a touch of the hand in a difficult moment. Acknowledge the value of touch and understand what it means for you.

To wrap up this chapter, I'd like you to take a few moments to fill in the spaces on the next page or in your journal, based on the idea of moving yourself from deficit to surplus.

Ask yourself: What in your life pleases each of these senses? What kinds of things activate each of these senses, heighten these senses, and make you feel the most you?

REDISCOVER YOURSELF REDEFINE YOUR LIFE

	When I need to move from: Defeated to Capable Stuck to Satisfied Empty to Enough Full to Fulfilled I will...	EXAMPLES: I will ...
HEARING		Identify music that I love and create playlists for different parts of the day (gym, sleep, car rides).
SIGHT		Commit to making eye contact with the people I am interacting with and make time to go for walks in nature without being focused on my phone.
TASTE		Devote time to finding three staple meals that fuel my body and taste good.
TOUCH		Hug my loved ones more frequently and longer.
SMELL		Practice opening my windows on nice days and put essential oil diffusers in each room in my house.

CHAPTER NINE
THE FIFTH FACET

SPIRITUALITY: ACKNOWLEDGEMENT OF THE EXISTENCE OF GOD AND A REALM OUTSIDE OF WHAT CAN BE INTERPRETED THROUGH OUR SENSES

As you already know, faith is the foundation on which the rest of this pursuit is built. Deciding to develop a personal relationship with God and committing to a pursuit of who He intends you to be is pivotal to the promise in this book.

FAITH OVER FEAR

It is my experience that so many people are struggling in the faith department. Some have lost hope; some have been led astray; some are resentful towards religion, and some are traumatized by the way religion was forced upon them as a child.

If any of these things apply to you, if you're struggling in some area to articulate your beliefs—that's okay. God will continue to reveal the next steps to you, will continue to work on your heart and the circumstances that surround you.

What I'd like you to become aware of, though, is whether you are operating from a place of faith or fear. And then I'd like you to commit to choosing faith *over* fear as often as possible.

Rate yourself on a scale of 1–5 for each of the statements below, with 1 being "This is totally not me!" and 5 being "This is definitely me!"

1. I have to have every single detail in place before I make a decision.
2. I struggle with executing the plans God puts on my heart.
3. I know that things that have happened to me in the past continue to hold me back.
4. I often feel unsure about what my next steps are.

If you scored between 0 and 10, congratulations! You are operating from a place of FAITH more often than not. If you scored between 11 and 20, Fear is winning. Now that you're aware, anchor even further into your own pursuit. Let's go!

ONE DAY WIN

It is easy for us to worry. It is easy for us to wonder whether or not we are doing what we should be doing, the way we should be doing it. It is easy for us to get lost and distracted, pulled away from the narrow path that we know we need to be on.

My hope is that you can begin to embody the idea of course-correcting your choices, little by little, so you can experience a life you can enjoy, knowing you have redefined your life according to the plan God has for you.

The Bible tells us in Matthew 6:34, "Therefore do not worry about tomorrow, for tomorrow will worry about itself. Each day has enough trouble of its own."

This is why I have been so focused on assisting you in creating *days* that are full of the things that really matter, of the things that make you feel most alive. Stringing together a good morning, with a good afternoon, with a good evening, to have a good day.

Then, stringing together one good day, two, and three. It is when we begin to think we can control the future, when we find ourselves dwelling in the past, or when we, for whatever reason, cannot allow ourselves to be here in the present that we begin to worry. That worry turns to panic. The panic into anxiety. The anxiety into loss of control. Loss of control turns into

> "Give us this day our daily bread..." —Matthew 6:11

despair. Not to mention, tomorrow isn't promised to anyone. It is *this* day that we want to focus on.

In one of Pastor Steven Furtick's messages, he shares how so many of us get stuck where we are because we think things will change "one day *when* [we] have more resources, more clarity, when [we] know enough, when [our] kids start acting right ..."[9]

He challenges us to shift our perspective from a One Day *When* way of thinking to a One Day *Win* mentality.[10] He says, "If we get a one day win, on top of a one day win, on top of a one day win, on top of a one day win, one day we'll be telling our kids— One day WHEN, I made a decision to get a one day WIN ..." we finally made the change we had been longing for. (Sound familiar?)

> "'For I know the plans I have for you,' declares the Lord, 'plans to prosper you and not to harm you, plans to give you hope and a future.'" —Jeremiah 29:11

In other words, if we can trust God enough to take these baby steps, to get a One Day Win, there's going to come a time when your testimony will declare that one day WHEN you decided to get a ONE DAY WIN, your life finally changed for the better.

In another message, Pastor Steven says, "Do not let what's *behind* you let you miss what is *before* you," encouraging us to leave the past behind us and activate a faith that looks forward. Instead of focusing on what we have lost, we must focus on what we have and fix our

eyes on what is ahead, knowing that God has "plans to prosper you and not to harm you, plans to give you hope and a future."[11]

The Fifth Facet, Spirituality, also focuses on having hope for the future. It is my belief that it is necessary to always have something to look forward to—preferably with an idea of the steps to get you there. Without a forward focus, it is easy for us to remain right where we are or to get swept away by life's currents and end up somewhere we definitely do not want to be.

Additionally, having something to look forward to fosters excitement and can serve as motivation for particular goals and plans. As Pastor Steven has said, we must give our faith something to look forward to. And as I have already mentioned, in order to move forward, we must be able to embrace where we are, to believe that everything that we have experienced has brought us to this moment, has created us to be exactly who we are. That we have this Liminal Advantage to launch us forward and that in this moment, right now, we are able to choose what it is that we take forward into our futures with us.

PRAYING IT FORWARD

A nonnegotiable for moving forward is prayer. It is a way for us to intentionally talk to God about anything and everything that is on our minds. It also gives us the opportunity to do what is most important—listen. If I'm being totally honest, prayer used to seem like a chore to

me. When I first incorporated regimented prayer time into my life, it was because I wanted to support someone close to me who was experiencing some radical change in his life. I was there for him when he needed me, but God called me to do more. God put a tug on my heart to pray for him for thirty days consecutively, without telling him, something I now refer to as Praying it Forward.

The Bible talks about fervent prayer, meaning prayer having or displaying a passionate intensity. Although I have always regularly talked to God and prayed throughout the day, I wouldn't have ever described myself as someone who prayed fervently.

But, this man, who I was divinely tasked to pray for, is an example of someone who prays fervently, specifically, seriously. And because I was being called to stand with him in his requests to God, I wanted to pray fervently, too.

Two of the most important things I learned from his preferences pertaining to prayer were the significance of dedicating time and space to pray. For example, we would set alarms or reminders on our phones for specific times of the day to pray for one another or individually for particular things. He also dedicated a closet in his home as the primary space for him to talk to God. This inspired me to identify a dedicated Prayer Chair, with an end table to the right, where I leave my Bible, devotional, and journal so that they are always there each morning when I start my day or anytime I need some emergency time with God.

At first, setting aside this prayer time was a challenge for me. Dedicating actual space and time, regularly and repeatedly for the same requests, asking God daily with

the same passionate intensity. But I wanted to build this new behavior. I wanted to slowly integrate a new practice in my life that was not just for these thirty days, but for, well, forever.

Because the call to pray in this way for him was so strong, I was adamant about my prayer time each day. I wanted to emphasize the prayer for his peace and for clarity around the situation that was becoming more difficult for him to navigate by the day. Each morning, I would pray from my Prayer Chair, and each night I would kneel down, next to my bed, bookending my days. I share this with you because this practice was not my norm. Up to this point, I would have casual conversations with God. I would pray when I could throughout the day, in the car, before meals, in times of need. For this experience, though, I wanted to fully surrender. I wanted God to know how serious I was. I wanted to truly lay down the requests I was making and turn them over to Him in full faith.

By deliberately choosing a time and place for prayer and by following the tug on my heart to pray for this man in my life for thirty consecutive days, I was able to challenge myself in a new way, make a healthy deposit into someone else's life, and take action by participating in something that God calls us to do.

What I also realized, as the days went by, was an increasing feeling of obligation to complete the thirty days of prayer. It was like I could feel the compounding effects of my regular prayer. It was as if I could witness the movement of mountains. And because it wasn't something I was doing for myself (because let's face it, this entire

book has been about normalizing the prioritization of ourselves), I was more interested in actually completing the thirty-day challenge God had set me out to complete.

Here is what is cool, though, about this experience: by the end of the thirty days, I was not just Praying it Forward, I was having a full-blown conversation with God about all kinds of things. I found myself getting more vulnerable in my conversations with Him. And when my conversations with God started to happen more regularly and more authentically, my entire life began to change.

My days seemed longer, far less stressful, and I felt surrounded by love on a daily basis. When things did come up that were out of my control, I felt anchored in truth and in love. I felt God working around me constantly, ordering my steps and directing me in the places I should go. I felt a sense of weightlessness and relief knowing that as long as I incorporated God into my life, I would always be provided for, and I would have the eyes to see and the ears to hear. I began to pray more specifically. I began to shift my focus to the things that I was really grateful for and the life I was living was suddenly so much more beautiful.

I am not going to give you any hard and fast rules about what you do with this or how you incorporate it into your life. I trust that God will guide you divinely in the way that it needs to happen for you. What I'll share from my experience is that at first these conversations felt forced; they felt short, and sometimes I didn't know what to say, or I didn't want to do it at all. What started out as an almost uncomfortable and unsettling call from God to pray for someone for thirty days turned into regular and thorough

conversations with God, conversations that felt like talking to an old friend.

Incorporating a Pray it Forward initiative into your life is meant to start off with your best foot forward and anchor your intention into what this all is truly about, anyway: the relentless pursuit of yourself so that you may show up for others in the best way that you can.

Not only will you feel good about pulling a loved one into your prayer life, but you will also be building a behavior that has the potential to change your life forever.

Additionally, my hope is that this urges you to step outside your comfort zone and start thinking about your time management and discipline when it comes to a goal that requires effort (even seemingly small effort).

And a friendly reminder—we aren't aiming for instant gratification or overnight results. This is a pursuit—a guidebook—one that screams strategy and behavior building, and this, my lovely friends, is part of building a new behavior. Or, for those of you who are already doing something similar on a daily basis, it is exercising the muscle of something you want to reinforce.

GRATITUDE

Gratitude is another important part of this journey. On the days I make time to acknowledge the things I'm exceptionally grateful for, my days are much better. I know when I start to become resentful, bitter, and overwhelmed, it's typically because I haven't anchored myself into my gratitude

> "Feeling gratitude and not expressing it is like wrapping a present and not giving it."
> — William Arthur Ward

practice, I haven't counted my blessings. It is also important to be vocal about the things and people we are grateful for. And this can sometimes be hard to remember to do, or it could be uncomfortable to express. I once read a quote by William Arthur Ward that said, "Feeling gratitude and not expressing it is like wrapping a present and not giving it." Kind of silly, huh? Let's make a commitment to improving in this area and finding meaningful ways to express our gratitude to those we love and appreciate it. A little goes a long way.

Remember, this journey is unique and specific to you. We are not trying to compile a checklist of things you need to do every day in hopes that it magically fixes everything. This is about the rediscovery of yourself, the unlearning of all the things that may have been imprinted upon you, and activating your faith in a way that makes you want to be willingly obedient, to give cheerfully, and to pray without ceasing.

So ask yourself:

- ► Are you living from a place where you are choosing to lead with FAITH over fear?
- ► What are you afraid of?
- ► Are you struggling in your faith? If so, why?

- What is it about your faith that you can't do without on a daily basis?
- How can or do you activate your faith?
- Who do you pray for? Why?
- What time of day will you set aside for these conversations with God?
- Do you have a dedicated Prayer Chair, Prayer Closet, Prayer Room? What makes it special?
- What can you do that will help you to make this a part of your routine?
- What three things are you most grateful for, right now, at this moment? Why?
- Who in your life needs to hear that you are grateful for them?

PART III

TIME TO TAKE ACTION

It is now time to take action. Here, in Part Three, I'll be guiding you through the Five Steps to Fulfillment, where we will tie together everything you've learned and uncovered in Parts One and Two.

The Five Steps to Fulfillment are:

1. Accept Your Prison of Becoming.
2. Claim Your Liminal Advantage.
3. Make Your PACT.
4. Rediscover Yourself.
5. Redefine Your Life.

As you should now be aware, we are born as unique and special individuals, who, over time, take on the beliefs, thoughts, traits, and characteristics of the world around us. Some of those things can be aligned with our true nature; others are not, and therefore act as a means of long-term conditioning that takes us further and further away from our true selves, slowly, over time.

In addition, we evolve as our lives and the conditions around us change. So, something that may have worked for us in the past may now be obsolete. We may love something so much in one season of our lives and realize later that it has become insignificant. We will continue to expand, new levels of who we are and what we need will emerge, and these Five Steps to Fulfillment will assist you in keeping up with yourself as you continue to become more *you*.

When I originally began this kind of work in personal development, I was trying to be someone I was not. I was putting on one mask after another, seeing what would best fit. But it wasn't until I dropped the masks and went inward that I truly began to gain momentum towards the person I had been longing to be, the person I was designed to be, without the world's comments, without the need to fit in, without the ache of being successful, without the wax.

I also realized I needed to anchor into my plans and my purpose several times a year so I wouldn't lose sight of what I had set out to do and so I could adjust where needed to ensure I was still being true to myself as things changed.

By incorporating these Five Steps in my life, I have been able to commit to relentlessly pursuing myself, creating deeper layers of confidence, and finding fulfillment in new areas of my life, over and over again.

We must have a system in place to reacquaint ourselves with our true nature, our true selves, the essence of who we are, at our core. We must regularly prioritize the reestablishment of our relationship with God, the truth, and what actually matters. And not just once, but regularly, as our lives continue to change and as we continue to evolve.

> "Therefore I do not run like someone running aimlessly; I do not fight like a boxer beating the air." —1 Corinthians 9:26

Otherwise, we will continue to wake up each morning, walk ourselves into our cages, and lock ourselves in. Why? Because it is familiar. We will remain in our Prison of Becoming doing

what the world tells us to do, running frantically towards meaningless goals, exhausting ourselves aimlessly, without purpose, without joy.

Realize that there has been an evolution within you simply in the time it has taken you to get to this part of this book. An earlier version of you, the version of you that existed before reading this book, longed for something different, something compelling, something that would be encouraging and help you to feel capable and worthy of a life worth living, a story worth telling.

But now, you have a heightened awareness. You are interested in uncovering, rediscovering, and remembering who you are. And as we move through these Five Steps, you'll be creating a framework, utilizing everything that you have learned and uncovered so far. This framework is designed for you, by you, and will work every time to bring you the peace you need to create balance and make sustainable progress, not just for now, but for every version of you that emerges as you continue to learn and grow.

As we begin, realize that we are focused now on redesigning your life based on what you have experienced up to this point and the desires that God has on your heart now. You will be required to peer through the lens of the Surplus Self to forecast what you believe will be the best next steps to take. Dedicate time and space to completing these Five Steps so that you're set up to experience your Best Day, Every Day. The best part is, you can (and should) come back to Part Three of this book any time you feel yourself outgrowing your current circumstance. Or, consider allocating time several times each year to Review

and Reset, revisiting Part Three of this book purposely, to ensure you are on track and remaining true to yourself.

DEFINING CONFIDENCE

As you redefine your life, it will be critical to take note of your emerging confidence. Confidence is defined as a feeling or consciousness of one's powers or of reliance on one's circumstances. Another definition is the quality or state of being certain. Another is the faith or belief that one will act in a right, proper, or effective way.

Is it safe to say that you have been lacking confidence? That you have felt instability and insecurity in the areas of your life we have discussed? Can you agree that as you spend time sorting through the thoughts in your head and the prompts that I've given you, that you've become more clear and more confident in what you enjoy and don't enjoy? What you want and don't want? What you need and don't need?

I've realized that there are different kinds of confidence. My prayer for you is that you develop confidence in the following areas that I've named and defined for you here. Having this confidence will then fuel and inspire you to continue taking sure steps forward.

FIVE TYPES OF CONFIDENCE

Time Confidence

Time Confidence is the feeling you get when you take agency over your time and redeem time in a new way, trusting yourself with your decision-making pertaining to your schedule while also protecting your time from unwanted distractions.

Financial Confidence

Financial Confidence is the feeling you have when you know exactly where your money is, where it has come from, and where it is going. It has nothing to do with how much or how little money you earn or spend; it has everything to do with being clear about your relationship with money and the behaviors you have around money.

Commitment Confidence

Commitment Confidence is the feeling you get when you gladly do what you say you're going to do. It's when you confidently commit to plans, projects, tasks, and trips. It's when you say yes to the things that you want to do. And no to the things that you do not want to do. Without judgment, without guilt, without shame.

Decision Confidence

Decision Confidence is the feeling you get when you make a decision on your own and trust the decision you made, knowing that it came from a place of integrity, regardless of the pressure, shame, guilt, or other negative projection that may be placed on you by another person as a result of the decision. Decision Confidence is the opposite of decision fatigue. Instead of the feelings of overwhelm and exhaustion, you feel sure and clear.

Self-Confidence

Self-Confidence is the feeling you get when you trust yourself, when you feel that you are being true to yourself, when the choices you are making move you closer to the person you want to be and further away from the parts of you that you may want to leave behind. It is when you feel sure, equipped, and capable of taking your next steps solely from a place within.

Confidence is so important when it comes to taking action. Personally, I think that this is the most important takeaway in this book. Everything that has been shared up to this point has been in an effort to prepare you for this—to take back your life one moment at a time by getting clear about the kind of life you want to live so that you can confidently create the life of your dreams. By now, you should have just about everything you need to do just that.

CHAPTER TEN

THE FIVE STEPS TO FULFILLMENT

You are the one who is in control of freeing yourself from your own Prison of Becoming. The version of you who picked this book up may have felt helpless, powerless. My hope is that you have more awareness and confidence that YOU actually can change this. It might not happen tomorrow or the next day, but YOU can change your life. You have the keys to your prison in your pocket and you can get out. What a relief! What strength! What empowerment! With this new information, the information that you are capable of freeing yourself, you now have information that many people in this world will never obtain.

As I send you off, I want to be able to give you some actual actionable things that you can do to gain confidence and make this change in your life. So, clear some space in your journal and let's go!

STEP ONE: ACCEPT YOUR PRISON OF BECOMING

Step 1 is Accepting Your Prison of Becoming. Accepting that, yes, this is where you are. Instead of being angry, resentful, or comparing yourself to someone else, just accept that you are where you are. And that that is okay and enough. Remember the painting? The butterfly? This is your moment to become aware of all of the possibilities that await you, outside of your own prison. Are you ready?

To be clear, I'm not telling you to just notice your prison, become aware of your prison, outline your prison, and blame everyone else for the prison. I am telling you to accept the prison. Acknowledge that, yes, this is where you are. Take accountability for contributing to being there. Admit that you have been walking yourself into your prison and locking yourself in each and every day, with the key to the prison in your pocket.

Realize that you may find yourself in a prison that pertains to only one aspect of your life or that you may be locked up in multiple areas. Often, we will leave one prison and walk into another. There will be things that you'll have to continually look at within you so that you can be aware of these prisons.

So ask yourself:

- ▶ In which areas of your life are you currently feeling imprisoned or restrained?
- ▶ What parts of you feel constricted and limited?
- ▶ Do you notice particular areas of your life where these feelings stand out more?
- ▶ If so, what are they?

It's also important to note that there is a part of you that feels safer *inside* the prison. There is a part of you that embraces fear because it is familiar. Do not run away from that part of yourself, thinking that you'll find your answers elsewhere. Instead, come into relationship with that part of you. Have empathy for that version or part of you.

So ask yourself:

- Who are your cellmates that you have become so well acquainted with?
 - Examples: anxiety, despair, victimhood.
- Who are you without them?
- Who are you *without* the scary thing that you can point at and blame?
- What makes you scared or nervous to become that version of yourself?
- Can you articulate why?
- What part of you prefers to stay stuck?

Another effective technique for this is to let the other parts of you swoop in from a higher place of strength and understanding and allow yourself to be seen and heard. Imagine that you are speaking to that part of yourself and instead of shaming, hiding, or resenting that part of you, have a conversation that includes the following statements. Be sure to jot down any feelings or thoughts that arise as you're allowing yourself some time to understand parts of yourself that you may not have encountered in quite some time.

> **I see why you're stuck here.**
>
> **I've seen what has happened to you.**
>
> **I see why you've been in this prison, why you think you're not enough.**
>
> **I understand why you believe you have to continue doing and becoming more.**
>
> **What you have been through is HARD.**
>
> **What they did to you is not okay.**
>
> **I see you, understand you, and accept you.**
>
> **But we do not have to stay here forever.**

Just as you would do for your own child or someone you love, you must swoop in to rescue those parts of yourself that are afraid. That may be too weak to move. And you need to walk into that prison like God sent you there and say, GUESS WHAT? We're not doing this anymore. We've been doing it this way. We've felt protected and safe this way, but we are now drawing a line, we are taking the key out of our pocket, and we are heading out of this prison and into a new life.

In my experience, I constantly felt like I had to do more, achieve more, produce more, in order to add value to who I

was. For years I felt like I wasn't enough (and I still struggle with this!) But I realize that ultimately, this isn't true.

Although I still want to do more, to continue to improve, heal, and contribute to the world, I realize that there is never going to be a perfect time for me to take action. I will always find myself in a state of becoming, but instead of feeling incarcerated, I have shifted my perspective to see it as a pursuit.

Even if I was crawling or stumbling, I began to realize that failing forward was better than standing still. Because I was orienting myself in the direction of the things that I felt God calling me to do, I was setting things into motion, things that God could then work with and put momentum under.

I'm so grateful to have stumbled upon Jim Carrey's painting years ago, to gain awareness that not only could I free myself, but I *had* to, and so do you.

So ask yourself:

- ► Are you ready and willing to relentlessly pursue yourself?
- ► Are you ready to risk being seen in all of *your* glory?

KEY TAKEAWAY OF STEP ONE:

Name your Prison of Becoming. Where are you stuck? What feeling or situation are you aware of that is keeping you in a place of feeling incarcerated, like you are chained down and can't move forward? Do not overthink this. Just write.

STEP TWO: CLAIM YOUR LIMINAL ADVANTAGE

Once I had an awareness and acceptance of my Prison of Becoming, God was able to reveal to me that I was actually right where I needed to be, and so are you. No one on this planet has the same past, the same trauma, the same family, the same experiences, the same fingerprint that you do. And yet, we don't see this as important or amazing. So how can we not see that we are equipped in ways that other people are not or never will be?

If you can accept your Prison of Becoming and become aware of your liminal space—you can claim that you have an advantage. Instead of being rattled by the transition period, feeling resistance and like the world is against you, I challenge you to see this as an opportunity that can be leveraged, an advantage that only you have. Realize now that you are perfectly positioned for your next move.

To make this a little more concrete, ask yourself:

- ▶ What qualities do you have that came as a result of the things that you have gone through?
- ▶ What traits do you now possess because of the experiences you've had?
- ▶ What major lessons have you learned by going through things that you may categorize as major moments of defeat?
- ▶ What setbacks were actually setups?
- ▶ In which ways can you see that you actually are perfectly positioned?

- What things are going well in your life right now that weren't before?
- Can you believe and claim that you have an advantage? What is it?

It's great to have the adrenaline rush of walking out of your Prison of Becoming once and for all, but sometimes it can be overwhelming to claim this Liminal Advantage.

You may say to yourself, "Great! I'm out of my prison, but now I'm just ... standing here. In an empty hallway of liminal space." You suddenly have the awareness of being out of one stage of your life but not yet aware of what is next.

Remember, most people do see liminal space as catastrophic and it sends them into an existential crisis. It makes them feel insecure and indecisive. When you're in a transitional space, it is very easy for it to feel daunting, like it will never end, or to begin questioning everyone and everything.

But what you have to lean on is the fact that you're in a hallway that you and *only you* are in. You are on a path to becoming the most virtuous and victorious version of you. You can embrace the sentiment of "I'm out of this prison! Wow! I can breathe. I feel free! And I am excited about where I will go next!"

The challenge here is to become as present and as in the moment as possible, to realize that you are right where you need to be, that where you are right now is a purposeful place to be.

I'm not recommending that you disregard or shove down any of the tough moments that you've been through, but I dare you to ask yourself:

If things can change on a dime in a bad way, why do I not believe that things can change rapidly in my favor?

If you can accept that terrible things can happen and make an impact on your life, you should also believe that God can come into your life and redeem those moments for your good.

Once you see and claim your Liminal Advantage, it becomes time to commit to yourself, to actually begin to get clear about how you will honor yourself and your transformation.

Remember: liminal space is the term we use to describe the in-between phases of our lives, the transition periods. Also remember that you are uniquely positioned, with a past that no one else on this earth has experienced. With an *advantage* that no one else on this earth has available.

Chances are, this concept is new to you—and that's okay. I'm already convinced that you are *exactly* where you need to be. Hopefully, this exercise will assist in convincing *you*.

Consider these questions and write about them in your journal. The goal here is to begin to reframe your current situation from one that may feel heavy, stressful, and like THE END to one that has some hope and optimism attached to it.

> **Why are you perfectly positioned for your next move?**

> **What is YOUR Liminal Advantage?**

> **In what ways have you been provided for in ways that you can't explain?**

Has there been anyone to enter your life that has
helped you through some of your tougher times?
If so, who? And how did they support you?

What things have you gone through that have
brought you to this current moment?

What experiences have you had that have forced
you to grow into the person you have become? How?
What did those experiences require of you?

What steps do you know you need to take to
become actually who you are potentially?

What is holding you back from leaning into this
liminal space and using it to your advantage?

KEY TAKEAWAY OF STEP TWO:

Claim your Liminal Advantage. Take a few moments to succinctly jot down some words that convey the strength and edge that you have because of everything you've ever been through that has brought you to this moment.

STEP THREE: MAKE YOUR PACT

As we discussed before, when you think about a pact, you think about an agreement, a contract, a covenant. A pact is clear, you know what it is, what the parameters are. And you are, in good faith, shaking on it and setting it into effect. The pact we are making here is our Persistently Aligned Commitment to Transformation, the promise we are making to ourselves to see things differently, to act differently, and to step into a life where we experience more confidence, fulfillment, and joy.

This is where we get clear about the pact you're making with yourself. To do so, you'll have to realize several things:

- ▶ You will always be in some form of liminal space.
- ▶ You will always be identifying, breaking out of, and walking into new prisons of becoming.
- ▶ You must switch your outlook to one that focuses on outcome-based goals to process goals, in other words, it is the journey we are concerned with, not the destination.

It can be a relief to realize you no longer have to focus on outcome-based goals (I want to lose 40 pounds) and you can now embrace the idea of a process goal that focuses instead on lifestyle changes and a lifelong pursuit of who you are, and who you'll continue to be. (I want to have a healthy lifestyle that includes eating well and moving my body.)

When you commit to progressively increasing and upleveling, you'll begin to see that any forward progress is

progress forward. Any baby step, any small win, any action taken (even if it isn't the *right* one) is better than none at all. You'll begin to allow yourself to move forward, closer and closer to the thing you have set out to do, which, in this case, is to become more you.

As you make this pact, you are giving yourself permission to live imperfectly, to fail frequently, to enjoy the mistakes, and to learn from the lessons. You'll begin to embrace the rediscovery of the parts of yourself that have been shoved down, shamed, dormant. You will find excitement in the day-to-day and accept that you will constantly be working on something—that there will always be imbalances in life, places where you are feeling unfulfilled, where new needs are emerging.

So instead of locking yourself in that prison and thinking everything is going to be perfect at the same time, claim your advantage, make this pact, and choose to become *actually* who you are *potentially*, over and over again.

Focusing on your personal development does not mean that you'll be exempt from entering prisons again, but what you'll notice is that when unexpected things happen externally around you, you will be more aware of how you feel about these things, how to respond to these things, or what you expect out of the situations that present themselves. Discerning now what you are available and not available for allows you to spot what you will not tolerate from a mile away so that a future version of you will not get caught up in the things that have, for so long, kept you off the path of who you're meant to be. You will

have already had a conversation with yourself, you will have already made a decision about these things that are of importance. That way, you can feel good when you say yes and you will feel good when you say no.

This level of authority and confidence over your life requires making this pact to relentlessly pursue who you are. Uncovering, investigating, rediscovering, digging as deep as you can—you are worth pursuing, you are worth getting to know, you are worth discovering and it is such a beautiful process.

This is all about your willingness to start over, to create long-term, sustainable, behavior-based change that leads to a happier, healthier, more beautiful life. And it starts with you committing.

As you already know, I had found myself at a place where I was starting over. Releasing control, combating the negative self-talk, and laying aside the distractions I knew would hold me back was not easy. It is still not easy. To help, I began my pursuit and anchored into my pact by doing two things, two things that I will now guide you through.

The first, is to get specific in your commitment to yourself by unpacking anything that may get in the way of your Persistently Aligned Commitment to Transformation. Exposing these weaknesses, triggers, and obstacles up front gives them less power and you more confidence as we get you ready to make *your* pact.

Grab your journal and spend some time working through the prompts below.

Persistent

- What is your current relationship with being persistent?
- For what reasons do you typically give up on the things you set out to do?
- When you give up, how does it make you feel?
- When was the last time you kept a promise to yourself? How did that make you feel?
- What is something that is currently holding you back from going after the life you want to live?
- What is something that would make it easier for you to pursue that life?

Aligned

- What are some things in your life that are weighing you down and keeping you from remaining obedient?
- What are the sins or behaviors that you are prone to partaking in that hold you back, distract you, or are destructive to your life, relationships, and goals?
- What are three words that come to mind when you think about the vision for your life that you'd like to be most aligned with?
- What byproducts do you experience in your life when you are living in alignment?

Commitment

- How do you feel about making a commitment to pursue yourself?
- What negative self-talk arises when you realize you're about to do something new for yourself, for your life?
- What is something you can do that will help you to keep this commitment?

Transformation

- How does it make you feel, knowing that you are committing to a pursuit and releasing your need to be in control?
- What can you do to prepare yourself to be disciplined enough to stick with this pursuit while also leaving room for God to move in your life?
- How do you know that you are finally ready to rediscover yourself and redefine your life?

The second exercise I did involved creating a Pact Prayer that reminded me of the purpose of this pursuit. Plus, I needed all the help I could get. I recommend that you take some time to create something meaningful, too. Something that you can put on your bedside table, the background of your phone, or in the mirror in your bathroom.

Realize that this is simply a starting point. You can edit this at any time and change the ways you refer to it. What's important is that you get as clear and connected as

you can now with something that moves you. And if this is totally new to you, use my Pact Prayer, for now, until you are guided otherwise.

> *Lord, I am ready for this commitment. I am ready to commit to myself in ways I never have before. I trust that you have positioned me perfectly for my next move, with the right tools, the right resources, and the right people in my life. As I commit to myself, what I'm actually doing is committing to the plan that You have for me. Help me to see each next step, help me to hear Your voice and see what it is that You are trying to show me. Help me to put my own fears, worries, and agenda aside so that I can show up in the most authentic way, the way You intended me to be.*

Make way for this pursuit by clearing out anything that may be in the way by taking time with the above prompts. Create your own Pact Prayer, something that you can read daily that will help to remind you of what you've set out to do. Reading this Pact Prayer each morning when you wake up is now nonnegotiable. Do not lose sight of your commitment.

KEY TAKEAWAY OF STEP THREE:

In this season of your life, what pact are you ready and willing to make to yourself? Write your own prayer, and set your own goals. Note your nonnegotiables. Anchor into the knowing that your new life begins today.

STEP FOUR: REDISCOVER YOURSELF

Did you know that our fingerprints are fully formed by our sixth month in the womb?[12] And that no one else in the world has the exact same fingerprint as you? Even identical twins have different fingerprints. I know that this most likely isn't new information, but can we please just take a moment to reflect on how miraculous that actually is? I mean, think about it. Almost eight billion people on the earth today. None of them have the same fingerprint. Pretty incredible, right? Now think about the over one hundred billion people who have ever lived on earth, each with unique fingerprints. Astonishing.

> "Before I formed you in the womb I knew you, before you were born I set you apart." —Jeremiah 1:5

With that being said, fingerprints are one of the best ways to identify a person. When we touch something, we leave what is called a unique impression on whatever it is that we touch. That fingerprint matches us, and only us. The other interesting thing is that the same fingerprint will continue to regenerate over and over again, as we grow, as we age, as things change.

I feel like it's the same when it comes to who we are, what we value, what we prioritize, and what we need—that things may change, the world may change, but the true essence of who we are not only remains, but wants to live and leave an impression.

The point I'm making is that we can't and shouldn't run from who we are. We have been designed specifically. We have been created uniquely. We are literally one in billions. And somehow, we have been convinced that that isn't absolutely phenomenal. That *we* are not absolutely phenomenal.

We are meant to find out more about who we are innately. This rediscovery and pursuit of who God has intended us to be is a beautiful mission to live filter-free, authentically, and at peace. When we do this, we can feel at home in our bodies, confident in who we are and how we fit into this world, and we can leave our own unique impressions on those we have the opportunity to interact with while staying true to ourselves.

Whether you realize it or not, we have actually been doing part of this work, this rediscovery, during the entire time you have been reading this book so far. We've covered a lot of ground, sorting and organizing a lot of information, a lot of your thoughts, and hopefully, your wheels are spinning.

Let's review the work you've already done pertaining to the Facets of Fulfillment. They were: Schedule, Significance, Satisfaction, Senses, and Spirituality. (Note: If you are revisiting this portion of the book for a second (third, fourth, or fifth!) time, be sure to dedicate some time to go back to Part Two of the book to complete the activities so that your answers best reflect where you are now.)

In Chapter Five, I introduced you to the First Facet, Schedule, which included the Time Inventory Tool. By

now, you should have completed your Time Inventory, categorized it, and assessed it. Revisit your Time Inventory now to assist in answering the following questions:

- ▶ What was your biggest takeaway from the Time Inventory Tool?
- ▶ Where are you spending too much time?
- ▶ In what ways could you quickly adjust the way you are spending your time?
- ▶ What must stay? (Hopefully many of the items you labeled as Things You Enjoy.)
- ▶ What must go? (Hopefully many of the items labeled as Things You Do Not Enjoy.)
- ▶ What other findings are most notable after completing and categorizing your Time Inventory?

After getting a new understanding of how your time is currently being spent in Chapter Five, I then shared some information with you in Chapter Six that should have helped you to get clearer about why you aren't currently spending your time the way you'd like to. Take some time to reconnect with the activity you completed on Connecting to Yourself & Your Values. Then, take some time to compile your thoughts, making them more succinct by using the following prompts.

- ▶ In addition to reviewing your Pact Prayer each morning, what other daily nonnegotiables did you rediscover from this activity?

- ▶ Where is your secret place?
- ▶ If you were meeting someone for the first time, what would be the first things they notice about you?
- ▶ What do your close friends or family members know about you that others don't?
- ▶ What aspirations do you have that you are looking forward to *one day*?
- ▶ What stood out the most to you from the Getting Clear About Your FEAR exercise?
- ▶ What fear feels the biggest to you right now?
- ▶ What actionable steps can you take to begin to chip away at that fear?

What's interesting is that many times we can feel invincible by the time we get to this portion of a self-help book, only to realize we remain stuck, even after we've finished reading the book. This is why I had to introduce you to the information in Chapter Seven, which covered everything that had to do with Satisfaction, including the activity on moving from the Deficit Self to the Surplus Self. Take a moment to revisit that activity and refresh your memory on your answers.

Deficit to Surplus Exercise

Then, to get a little more clear about where you currently stand when it comes to your basic needs and level of satisfaction (especially when you are revisiting this in the future), use the 1 to 5 scale we used earlier, with 1 being "This is nothing like me!" and 5 being "This is exactly me!" and rate yourself on the following statements.

1. I regularly make time for the things I know I need.
2. I feel mentally healthy.
3. I feel physically healthy.
4. I feel safe and secure financially.
5. I feel safe and secure in my home.
6. I have people in my life I can count on.
7. I feel confident developing new relationships.
8. I am proud of where I am in life.
9. I feel free.
10. Pouring into others fuels me.

If you scored between 40 and 50, you are generally operating at a surplus. If you scored below 25, you're generally operating out of a deficit. And if you fell between 25 and 40, you're well on your way to operating from a surplus the majority of the time; you probably just need some more clarity and confidence. (Which is what you're developing here!)

Maslow's Needs in Motion

In Chapter Seven, I introduced you to Maslow's Needs in Motion. Remember, it is my belief that if we are well acquainted with the way we relate to each of the areas of need, and have a sound plan to be satisfied in these areas, we will have a solid foundation with needs that are met, allowing for the opportunity to have peak experiences regularly.

Here, I'd like you to note things you can do sooner rather than later in each of the categories below to move yourself daily from a deficit to surplus. Keep in mind that we are not focused on outcome-based goals. Doing so will perpetuate living in a deficit, and you'll continually want more. Instead, focus on things you can put in place in your life to build new behaviors, ones that are simple, make sense for you, and will move you from a full life to a fulfilled one.

Take a few moments to revisit the information you jotted down after answering the questions pertaining to Maslow's Needs in Motion in Chapter Seven. Pull three to five action items from each category and jot them down. I've added some examples for your consideration and inspiration.

Category	Action Steps	Example Action Steps
Sleep		- I will go to sleep each night by 9:30 and wake up to an alarm (without snoozing!) at 6:00. - I will have a cup of tea with my kids and read a book before bed. - I will put a diffuser on my nightstand to diffuse a relaxing oil each night.
Movement		- I will go for a walk a few times a week. - I will start wearing my Apple watch and pay attention to my steps and standing goals. - I will focus more on my water intake.
Finances		- I will commit to completing my Finance Inventory by a certain date. - I will close all old accounts. - I will open a savings account.
Family & Friendships		- I will schedule lunch or coffee with a friend to take place in the next 30 days. - I will attend a work function and try to connect with someone new. - I will coordinate a family lunch/dinner in the next 30 days.

THE FIVE STEPS TO FULFILLMENT 169

Category	Action Steps	Example Action Steps
Motivation		- I will set reminders on my phone with different motivational quotes that I know will inspire me. - I will put my Pact Prayer in places that I will see it often. - I will listen to a random motivational video online each morning on my way to work.
Laughter		- I will commit to being more fun, more often. - I will make time to watch a silly movie. - I will give myself permission to do something fun with one of my friends.
Misc		- I will commit to consistency over perfection. - I will let myself make mistakes. - I will give myself grace.

CHAPTER ELEVEN

TRIED-AND-TRUE TOOLS

Now, even though you may be feeling like things are fresh and new, you can't forget that life (as you currently know it) still exists. We can't forget about the goals, work, errands, family issues, and school functions to which you are currently obligated.

Just because we have identified that you are in a liminal space and willing to do the work doesn't mean that you'll snap your fingers and be through it. You will still be required to have capacity available for all of the trappings of the human experience—which means you will also continue to run into some of the same obstacles you are now.

I'd like to share some tried-and-true tools with you. This way, you'll be aware of some of the things I wish I would have known as I stepped into this new way of living and avoid some of the mistakes I made early on in this process.

Simplify

When I originally wrote this section of the book, I did not have Simplify positioned as the first tool. During an edit, I realized that without making the simplification of your life the primary priority, none of the other tools I'm sharing would be as effective. I share this with you because it truly is that important to follow what I'm sharing here. Simplifying is good. Simplifying is likely what you want and need. Simplifying is the thing that makes the rest of this make sense.

When I think about simplifying, I think about my dad and the neighborhood I grew up in, the one he grew up in. To this day, I could swear that the air smells different there; it just smells like home. The little patch neighborhood with one of the few remaining drive-in movie theaters in Pennsylvania sits just off the main drag, which likely has never experienced actual rush-hour traffic.

As you turn into the neighborhood, there sits a fire hall, one my dad and uncles used to volunteer for, where they probably had their first beers and cigarettes as preteens, and a fire hall where I danced The Electric Slide at I can't tell you how many weddings.

Then, the drive-in that doubled as the location for the Sunday flea market, where we used to enter with five dollars and leave with treasures. Where we used to hide our friends in the trunks of our vehicles to avoid paying their two-dollar admission to see two movies. Where the concession stand looks today exactly the way it did when I was a kid.

Further down is where my dad grew up, my grandparents' house, where one of my uncles now lives. Where we used to play under the grape arbor and sit in metal chairs with scratchy cushions.

In the yard, there's a rope swing with a piece of wood for the seat—a swing I swung on when I was my children's age. A swing my children now fight over.

A few alleys. A back road. Some more relatives. Some trails in the woods. The holly tree that still stands outside of where my dad's garage used to be. Where my little five-year-old barefoot feet would walk over the gravel and prickly holly leaves unfazed. Steps away from where I would run off to one of my neighbors, my great-aunt, who seemed to always have fresh banana bread. A sprint away from where I could always count on a cold popsicle from our other neighbors in the summer. Across the street from where I would play kickball with my cousins. Around the block from where we would create hopscotch patterns with sidewalk chalk.

Growing up, it was taking a walk around the block or doing donuts on the icy mall parking lot in my dad's old Cadillac. Being taken to piano lessons and forced to play for thirty minutes each day after school so that when nothing worked on my body but my fingers when I was eighty, I'd be thankful for it.

To this day my dad embodies a simple life. To some people, including me at different points in my life, simple is boring. To him, simple is being available for his daughters. Simple is dedicating walls in his house to photos of his grandchildren. Simple is peace and quiet. Simple is working hard. Building a frame for the same porch swing each time we moved.

Simple is using the same P38 can opener to open everything you possibly could since before I was born. It's not replacing something until it would cost more to fix it. Checking your oil before going on long trips. Saving your change, talking together on the porch and strumming a guitar.

As you begin to take steps towards redefining your life, you could find yourself feeling a lot like I did the day I decided that my Hot Pocket and I were going to take on the world.

And if you're no longer wanting to be lukewarm, I feel you. I get it.

> "For our boasting is this: the testimony of our conscience that we conducted ourselves in the world in simplicity and godly sincerity, not with fleshly wisdom but by the grace of God, and more abundantly toward you." —2 Corinthians 1:12

But this reminder to simplify is more of a message of caution, a word to the wise.

It is likely that much of the reason you've landed here, like right here, right now, with this book, is because you have felt stuck and want to be satisfied, that you have a life so full that it is bursting at the seams, and you want to trade it in for a fulfilled one. Do not get caught up in backfilling your life with a bunch of things that don't matter. And to be honest, even too many of the things that *do* matter can be overwhelming. Use this first attempt at redefining your life as one that aims towards balance and peace, towards rope swings and hopscotch, towards opening up time in your life that you can then assign to other things later.

Lids on Pots

Now, inevitably, you will come to realize that even as you simplify, you will still find yourself balancing different aspects of your life, wearing different hats. This is where my second tool comes in, one I picked up from my dear friend Nicole. Early in our relationship, I realized that Nicole was a hustler. She had been in corporate sales in an intense and demanding industry for years and always had a side hustle (or two) rolling while still showing up for her friends and family.

To keep things straight and semi-under control, she would discuss her day-to-day happenings as though each of her activities or projects were pots on a stove: one pot for her work situation, one pot for her family situation, one pot for this situation or that.

When we would talk about how her day was going, I would be able to gauge it by how many lids were on the pots.

On a great day, all of the lids were on the pots, and Nicole was happy.

On a mediocre day, some lids were on some pots, but the contents of other pots needed tending before they would lose control and bubble over. On these days, Nicole was busy.

On a terribly bad day, no one had a single clue where any of the lids were, the stove was on fire and covered in a mix of muck that had bubbled over from the insides of all of the pots. It was on these days Nicole either couldn't care less, was entering delirium, or was spending the day with me, avoiding real life.

The more time we spent together, the more I started seeing aspects of my life this way. This perspective supported the reality that there was always going to be something that needed attention and that I would have a running to-do list for the rest of forever. It made it easier to balance it all and accomplish what I needed to by not focusing solely on one thing at a time (that would be impossible) but prioritizing my pots so that everything is making progress, small win, by small win, and nothing burns.

Practicing this regularly taught me that it was okay to start something new without totally wrapping up something else and that I was capable of having many situations under control at once. It also helped me to understand that certain things need to simmer, being stirred only once in a while, while others need to be thrown into the oven for a set amount of time with my hands off them altogether.

And then, when I would have the audacity to really get things moving, I would harness the majority of the heat and direct it to the highest priority pot so that I could finish cooking it and make room for a new one.

Doing this allowed me to see that I could make massive change in one area, while still experiencing incremental progress in others, accomplishing what I want to, more strategically, and, most of the time, faster.

When I originally set out to redefine my life and navigate this new normal, I began to identify and prioritize my pots. At the time, I didn't have many, but I did have some, and I was ready to throw on my apron and walk into the kitchen like God sent me there.

My children, my family, my health, my income, and my relationship with God were high priority pots. The fascinating thing about this approach is that it lets us hold different aspects of our lives in proximity to one another and doesn't require us to totally abandon success in one area for success in another. All of our pots can hold equal or similar priority status, can be rearranged as often as possible, and can change altogether if needed, as we do.

Now that I had my priorities identified, it was important that I decide how I was actually going to prioritize them in my life. It is one thing to say something is a priority, it is another thing to act on it.

In order to do so, I had to be clear about what I would be willing to do in each of these areas of my life. I had to determine how I would be willing to show up for my friends and family, how I could better prioritize my health—both mentally and physically—what I could begin to do to change my financial situation, and how I could continue to anchor in and grow my relationship with God.

There was a lot happening in my life that was tough to navigate and hard to cope with—there was no doubt about that. But the one major thing I did have going for me was the fact that my days were suddenly wide open. What at first seemed to be a rock bottom now turned into a situation that allowed for a unique opportunity to revisit my priorities and to redeem my time in a totally new way.

Fire for Effect

By now, you should be considering the simple things that are most important to you, the things that really matter, as well as becoming excited about the priority pots that will be the first on the stove.

This next tool is one I originally learned from my manager, Rich, at a leadership training we organized for the frontline leaders of the company we work for. And it is going to help you to shift your perspective around how to approach implementing new things in your life and knocking things off your to-do list.

As an icebreaker for the training, I asked all of the managers to write a quote that inspired them or some advice onto a sheet of paper. I then asked them to fold the page into a paper airplane. We all stood up and released the airplanes simultaneously, with the goal being to catch one that was not ours. We then shared what was on the pages with the group, discussing the quotes and advice, and introducing ourselves.

One of our managers opened his paper airplane and read out loud, "Fire for effect." At first, many of us thought the writer was implying to terminate employees in a way that had an effect on the broader group. But when Rich claimed the quote and began to explain, we realized what the other veterans in the room already knew—that it meant something very different, something I began to apply across all the Facets of my life, almost immediately.

As a graduate of the United States Military Academy at West Point, Rich was sharing a military term that could

also be applied at work. He explained that when it was believed that enough data had been collected, when enough adjustments to have a desired impact on the target had been made, a directive to fire for effect meant the time had come to stop messing around and destroy the target.

The message I received as he spoke was that the goal behind firing for effect was to be as deliberate as possible. To go all in. To literally give it your best shot as though it were the only shot. To not waste precious time, resources, or energy on anything other than the actions that would produce the desired effect.

It resonated with me so much, mostly because I had viewed my life with this sense of urgency and importance for years. I was excited because I now had something to assist me in conveying it.

I'd like to challenge you to fire for effect in your own life. Yesterday isn't coming back. Opportunities may truly be once in a lifetime. This may be your moment to go all in, to give it all you've got, to take your best shot. You can always adjust later. And remember—if going to the gym, playing with your children, scheduling in naps, and baking pastries are high priorities for this season in your life, if these are the things you value, you better be allotting time for these things and firing for effect with the same amount of energy and intensity that you would for any other goal.

Leave the Light On

This next technique is one that I created and have been utilizing personally for years. You're going to quickly realize as you begin to simplify your life, identify your priorities, and become more deliberate with your energy than you may have ever been, that it may feel slightly alarming. You'll be making new decisions that support the kind of life you want to live based on the new, exciting things that you've discovered about yourself so far. But that doesn't mean it is always going to be as exciting for those around you. Believe it or not, you have people in your life, right now, who may not be serving the best version of yourself.

Maybe these people have hurt you; maybe they don't support you—maybe you've hurt them. Maybe there are people that you have been dragging kicking and screaming through the situations in your life, hoping they'll hop on your bandwagon; maybe there's a group of people who enable your old habits.

> "And if anyone will not receive you or listen to your words, shake off the dust from your feet when you leave that house or town." —Matthew 10:14

As you evolve during this pursuit of yourself, the person God intends you to be, there will be tension and resistance. You will be met with questions from people who do not understand your changed behavior. There will be people who become insecure as you suddenly begin to

choose yourself, your health, and your faith instead of the things and ways of your past.

And that's okay.

It has been, in my experience, that the people who have met me with the most resistance in my journey have been the ones to come around later, seeking the truth for themselves. Please learn something now that it took me years to uncover: God does not ask us to become spectacles. To be self-righteous or prove a point. Among other things, He requires that we act justly, walk humbly. And it is my belief that in this case, to leave the light on.

Leaving the light on refers to lovingly letting someone go. Maybe it is temporary. Maybe it is permanent. For a day, for a year, maybe for the rest of forever. What I want to encourage you to do, though, when you find yourself in a situation where you have to put some space between you and another, do so with a grateful heart, with a heart of forgiveness, with a heart that leaves the light on, just in case. There may be a day that comes when the world feels lonely and dark, where they feel as lost and astray as you may have felt when you picked up this book.

I have had people hurt me. I have been lied to, betrayed, yelled and screamed at, embarrassed, shamed. Harboring ill will in my heart for the people who did these things to me helps no one. Having a short-term perspective that is self-serving helps only me, maybe. Thinking that I am exempt from acting the same way and that my relationship scorecard is flawless is ludicrous.

Leaving the light on helps to balance the scales. It requires you to come to terms with your mortality,

with your humanness, and to truly deploy patience and forgiveness. It requires us to tap into a part of ourselves that is beyond our pride and underneath our need to be a so-called tough guy or have the last word.

Be able to recognize the need for time and space when it arrives. Receive it peacefully and prayerfully. And if you can find it within yourself and the situation, before you let rage, hate, and anger take center stage, draw your line, hold your boundary, but consider leaving the light on.

Slam the Doors Shut

Now some of you may be thinking there's no way you are leaving the light on when it comes to particular people or situations in your life.

And only you are going to know what applies.

I do want to hold firm in the challenge to at least have you consider leaving the light on in particular circumstances, requiring yourself to engage humility with a perspective that you wouldn't normally have.

> "The heart is deceitful above all things, and desperately sick; who can understand it?" —Jeremiah 17 9-10

The reason I say this is that we cannot always trust ourselves. We cannot always do the things that our hearts tell us to do. Acting from a place of emotion is rarely the best way to fire for effect.

In this case, we do have to consult with God, prayerfully, and be obedient. There will be many times we are directed to do things that *we* actually don't want to do. But we've already discussed the importance of surrendering to a plan that is greater than ours, so I'm just preaching to the choir here, right?

Just as we may sometimes want to let go of somebody that God would prefer us to leave the light on for, occasionally, we selfishly want to keep people around when we really should be slamming the door shut. This could pertain to particular people, behaviors, or activities. And these are most often the people, things, and circumstances that we already know are no good for us.

For example, many of us are aware of the implications of too much alcohol. Yet we justify participating in this lifestyle because it's part of our work, there's nothing else to do, or because Jesus turned water into wine. For some of us, that is a door that needs to be slammed shut.

Another example is a financial one. Burying ourselves in credit card debt and overspending to fill voids that are deeper than we could've ever imagined. For some of us, that is a door that needs to be slammed shut.

The most difficult one is clinging to unhealthy and toxic relationships. At a particular point, there are not enough excuses in the world to continue to tolerate the way some of the people in your life are treating you. You're staying because of the kids. You're staying because of the job. You're staying because you're afraid to be alone. I have said it before, and I will say it again—some of you have relationships that are gateways to the rest of the pain and

suffering in your life, and they are doors that need to be slammed shut.

Leaving the light on can be utilized in particular circumstances where you really aren't sure of the outcome, or you really don't know what to do, or maybe God is leading you to take some space temporarily.

Slamming the door needs to be deployed when the situation calls for a severing, when you can't just slowly wean yourself off whatever it is, when you really need to quit cold turkey and enact a higher level of discipline.

To be clear, this does not mean that we have to contribute to the mess or ugliness of the situation. Often, disconnecting from these types of things is hard enough. The best way to approach these situations is to do it as swiftly, deliberately, and clearly as possible, and then, hold the line.

You'll know which doors need to be slammed shut and which lights need to be left on—which parts of your life stay and go. You'll begin to experience more clarity and confidence as you continue along this journey. You will feel stronger and more aligned in all of the areas of your life because you have dedicated time to exploring them. You will feel at home in your body and in your life because you've gotten to know and honor the person you have become. You will feel excited and equipped for your future because you now have so many beautiful things to appreciate and look forward to.

Weigh the Stray

Weighing the stray is a great tool, especially if you regularly deal with overwhelm, stress, tendencies of getting distracted—or if you are a recovering people pleaser. As you begin to make changes in your life, it will be critical to stand by what the rediscovered version of you *is* and *is not* available for.

Weighing the stray refers to the choice you have when you notice yourself getting distracted from the promises you have made to yourself. The first component of this is being aware of it, which is what I am hoping you are picking up on now. The second component is having the discipline to stay the course on whatever it is you told yourself that you would.

Pastor Steven Furtick explains it well in this excerpt from one of his sermons:

> *When [I] give weight to that promise from God,*
> *When [I] give weight to the right things,*
> *When I have a clear sense of priority in my life,*
> *I'm okay if people are angry if I say NO*
> *Because my NO*
> *Is a YES to something that I already decided was more important*
> *Than what any given demand might require of me*
> *At any given moment.*[13]

He goes on to say, "If you don't sort this out, you will live in constant imprisonment to your own indecision."[14]

How do you feel about that? Convicted? Liberated?

It's kind of amazing to realize that with intentional decision-making you can free yourself from the feeling of imprisonment. When you're disciplined in standing by the desires God has put on your heart, the things you've promised to yourself, it allows you to say NO to other things from a more empowered and sure place. So, not only do we need to determine what we need to give weight to, but we need to know how to weigh the stray, when we decide to stray away from those things we have decided matter.

For example, if you know that reading each morning with your coffee is something that you value, and you receive a text message from a colleague about something pertaining to work during that time, you are faced with an opportunity to stray.

In this case, quickly answering the text message and returning to your reading may be something easy for you to do.

Or, answering the text message could daisy-chain into multiple messages, a phone call, having to get onto your laptop, dig through files, and then before you know it, you have to leave for another meeting and your quiet time with your coffee and reading has been totally hijacked.

Another example involves fitness goals. Let's say you're focused on working out four days a week and limiting yourself to a particular calorie intake.

You find yourself at work, and it's someone's birthday. You have the opportunity to indulge, to stray. Will straying today by having one piece of cake, or one soda, or one cookie, lead to you indulging tomorrow and the next day and the next? Does going out on Thursday night for a few

drinks lead to more? What is the likelihood that a decision to stray will lead to another and another? What is the cost of you straying off course? Of you deviating from the plan that you know works for you?

Weighing the stray is specific to you and your personal levels of commitment and discipline. Maybe you're committed and disciplined enough to indulge in a stray. Maybe other areas are a hard no. It is difficult to know these things without exploring it and thinking about it, so take some time now to do just that.

Hit the Ground Running

When I turned thirty-three, I was in a fancy hotel gym in Denver. I say fancy because it offered boxed water, fresh fruit, and there had to be a dozen Pelotons. I was in between business trips, and because I didn't have anything else happening, I decided to spend the weekend in Denver and celebrate my birthday, alone.

I booked a treatment at my favorite spa, watched the sunrise from Red Rocks Amphitheater, binge-watched my favorite shows in my robe with a tray of sushi and dessert on my lap, in bed. What started as an exciting solo trip began to morph into a depressing situation.

My mortality was setting in. My loneliness was ramping up. And each day somehow ended with me exhausted and crying. At some point, I began judging myself, the negative self-talk increasing, my own internal dialogue turning against me.

I should consider myself fortunate to be able to squeeze in a pit stop in Denver. To treat myself in all the ways I needed and wanted to. How could I possibly be unhappy after a ninety-minute hot stone massage and back-to-back episodes of *Grey's*?

So what if you're across the country from your kids on your birthday? They're with their dad, anyway. So what if you're sad that there's no party, no gifts? You're not a child anymore. So what if you're sad, and you don't know why? Deal with it.

I tried to rationalize what was happening, but then, I just decided to let myself have it. Instead of considering myself foolish for feeling these feelings and having this internal battle, I decided to finally let myself have the time and space that I needed to process what I needed to. To explore and experience, to be emotional and extra, to let myself derail, without resisting.

If that meant I needed to kick and scream and cry and eat unlimited amounts of tiramisu and cheesecake, I was going to let myself do it, without judgment. If it meant I needed to sleep in late, stay up late, call and vent to my girlfriends, maybe indulge in buying myself something nice, I was going to allow myself to do it.

But I promised myself that come Monday, I would hit the ground running. That by the time I got off the plane to my next destination, I would have this situation buttoned up.

Now, when deploying this tool—use with caution. You need to know yourself and understand your limits. Because

I had already committed to my sobriety, because I rarely overindulge in sweets and spending, I knew that I could survive being a little extra. I could let myself take a hot bath because I needed it to decompress, knowing I wasn't going to end up where I was in early 2020. I could order dessert each night during my trip knowing that it wouldn't become a habit. I could spend the day at the outlets trying on (and buying) designer shoes because it made me feel good, knowing that it wasn't going to set me back.

Had I not already fought and won these battles, I would have chosen different ways to allow myself to derail. I also knew that the feelings were temporary, the emotions were emoting, and that if I indulged too seriously, if I went too far, I'd regret it.

Once you become aware that you have been distracted, you've had something in your life that you needed to deal with and it took you away from what you know works for you, or when you permit yourself time to kick and scream a little bit, use this tool to give yourself some time to adjust and process.

The alternative is that you let yourself become totally consumed by the clamor, lose sight of your vision, lash out at your friends and family, binge eat for weeks, overspend beyond your ability, or you pick up bad habits that are hard to put back down.

Do not be all or nothing.

Permit yourself to do something to suspend your reality for a moment so that you can deal with whatever it is that you need to. But do so with a commitment to a

tactical landing at a particular date or time so that you can utilize the freed-up space that comes with letting go to hit the ground running forward, towards whatever is next.

In this case, I let myself have the long weekend. I felt everything I needed to feel, and I was dramatic about it. But by the time Monday morning rolled around, I was able to reel it in, get it together, and hit the ground running, feeling complete and ready because I honored myself in the moments I needed to.

The other part of this to consider is that if you have *time* to dwell on things, chances are you

1. Have a full life but not a fulfilled one, or
2. You are being carried away by the world, not anchored into what God has put on your heart.

As you find yourself getting clearer and clearer about what you value and prioritize, you will protect those things at all costs, including protecting them from yourself and your own self-sabotaging behavior.

Instead of being so okay with being swept away by your emotions and external circumstances, you will begin to see your dwelling and your pity parties as a waste of energy, taking precious energy away from something else, something that you've already decided is important and valuable to you.

Tried-and-True Tools Activity

Now that you've been introduced to several of my tried-and-true tools, I'd like to close out this chapter by having you use the activity below to score yourself on how well you currently operate in each of these areas by selecting the option that best describes your life now. Then, as we enter our final chapter, which introduces Step Five: Redefine Your Life, you'll already have an idea of what tools you may need to deploy to keep your pact to yourself and continue along in this pursuit.

Rate yourself on a scale of 1 to 5 for each of the statements below, with 1 being "This is totally not me!" and 5 being "This is definitely me!"

Simplify

1	2	3	4	5

| *I live a simple and peaceful life.* | | | | *I have too many things happening & am stressed daily.* |

Lids on Pots

1	2	3	4	5

| *I deploy exceptional management of my current responsibilities & projects.* | | | | *I am overwhelmed, spread thin, and defeated most days.* |

Fire for Effect

1	2	3	4	5

Creative and fresh energy is used on high-priority items.	My energy is drained daily and consumed by low-priority items.

Leave the Light On

1	2	3	4	5

I maintain appropriate boundaries with people in my life.	I have a poor relationship with boundary setting

Slam the Doors Shut

1	2	3	4	5

I have slammed the door shut on the behaviors, places, people and activities that are no good for me.	I need to deploy this tool immediately.

Weigh the Stray

1	2	3	4	5

| *I stay on task and remain disciplined when it comes to What I set out to do* | | | *I often make distractions or excuses for my decision to deviate from the plan* | |

Hit the Ground Running

1	2	3	4	5

| *I take the time I need to process a difficult situation, then I get back at it.* | | | *I typically dwell on situations longer than I should.* | |

If you scored between 0 and 10, congratulations! You are able to see life through the lens of the Surplus Self and take action confidently. Continue to sharpen your skills and remain vigilant as you move ahead.

If you're between 11 and 24, you're most likely ready to home in on what exactly is keeping you from truly pursuing yourself and what's next for you. That's great! Having this opportunity for improvement will help you get to your next level.

If you scored between 25 and 35, I see you. Honestly rating yourself is the first step in becoming aware of the

changes that need to take place. Remember—this is not an overnight overhaul. Be proud of yourself for making it this far and committing to a new way of being. The next chapter is going to help you sort out all the details as you redefine your life.

CHAPTER TWELVE

REDEFINE YOUR LIFE

As we continue forward into the fifth and last step, let's consider our ways. Let's reflect on what our purpose here is, why you may have picked up this book, and how you would like to show up differently for yourself and those you love. Let's stay anchored in the original pact you made to pursue the person God intended you to be, relentlessly, and do so with an eternal perspective and newly acquired confidence.

The book of Haggai reminds us: "Consider your ways. You have sown much, and harvested little. You eat, but you never have enough; you drink, but you never have your fill. You clothe yourselves, but no one is warm. And he who earns wages does so to put them into a bag with holes."[15]

Do we want to end up in this same situation? Working forever, without reward? Binge-eating, but never feeling full? Clothing ourselves, but never warming up? Earning and earning and earning, just for the money to slip away on worldly things? Seeking and collecting, buying and hoarding, only to wind up realizing that it will never be enough?

Instead of directing our focus on the things of this world, keeping busy in our own houses, doing the things that distract us and keep us from the life God intends for us, why don't we focus on the ways that we can live a wholesome, virtuous, and victorious life that glorifies God? A life that feels peaceful and simple. A life that we curate with our faith as priority. A life where our focus is on becoming *actually* who we are potentially so that we can confidently create and happier, healthier, more beautiful life and serve genuinely from who we truly ARE.

After all, this entire process came to be while I was navigating a new way to heal during quarantine. I began to curate ways to experience some of the best days of my life, those with the most peace, the most balance, the most presence, *without* all of the things I once thought I needed.

Getting clear about how we can incorporate these tools that I have introduced you to into our lives regularly will assist us in staying grounded in the life God intends for all of us. Having clarity, consistency, and confidence helps us to stay mindful and deliberate while also having a vision for the future. Additionally, as we get to know ourselves better, we can immerse ourselves in the things that help us to feel radically awake and alive, which, in my opinion, is one of the best ways to really experience the life and love God has intended for us all along.

Please don't stop here. Don't stop with the work you have done up to this point. Don't put this book down and avoid taking action. A new version of your life is available to you, sooner than you think, and it is up to you to create.

For a moment, just consider these questions:

- ▶ What would happen if you attempted to string together the moments of self-actualization that Maslow observed?
- ▶ What would happen if you attempted to take small baby steps that would turn your bad days into kind-of-good days and your good days into the best days?
- ▶ What would your life look like if you slowly moved the needle so you could get closer to a reality where you would have repeat experiences of your Best Day, Every Day?
- ▶ What if instead of aiming for a total overhaul and finding all of the answers overnight, you fell in love with the rediscovery and the pursuit of yourself?

Understand that by simply living, breathing, and participating in a new day, you are admitting that you haven't fully become who you will ultimately be yet, but just by living and continuing, and especially by picking up a book like this, you have committed to your own self-actualization, and that you are willing to keep going, to continue on.

The difference now will be that instead of feeling like you are stuck, or that you are wandering around the metaphorical hallway of liminal space with no end in sight, you should be able to now see and understand that you are right where you need to be.

With that, you'll be able to experience a new sense of agency, authority, capability, and confidence in your life,

giving you the tools and strength you need to continue moving forward in the creation of a happier, healthier, more beautiful life.

THE SEVEN-DAY RESET

The best way I've learned to initiate long-term change in life is to complete what I call a Seven-Day Reset. In this reset, we become nonjudgmental observers of our lives, becoming aware of what we do and how we move, without necessarily feeling any particular way about it. Doing this allows us to take some time to witness the way we are currently experiencing our days, what we are prioritizing, who we are interacting with, and what we may be missing. It also allows us some space to develop the level of confidence it will take to protect our time and what it is we need.

So often we make knee-jerk decisions to go to the gym five days each week, have family dinners every weekend, or save more money without totally understanding where we currently stand in those areas, the actual likelihood of us doing those things, or the real-life benefit (if any) of doing those things.

Instead of shooting from the hip, we will begin by taking one week to Review and Reset. We are basically ensuring that what we put on our Time Inventory is true while leaving space for life to happen and for you to notice the feelings and thoughts you're having about particular aspects of your life. This is not a week of action

and implementation; this is a week of observation. What you observe will indicate what needs to be changed, what needs to be changed will lead to action steps, and those action steps will be worked into the next piece of this puzzle in redefining your life.

Completing the Seven-Day Reset

The first thing you'll want to do is designate a seven-day window that best represents your normal life. Completing a Seven-ay Reset over a vacation, for example, defeats the purpose. It has to be done during your average week. On each day of your reset, you'll be required to do nothing other than observe the way you spend your day and then report back in the evening to reflect on and answer the below questions.

Just as I mentioned in the Time Inventory section earlier in the book, a pivotal part of this activity is you being honest. So, lying about the way you feel when it comes to how you're spending your time or skewing your reflection notes for whatever reason is only going to hurt you and your ability to make the change that you actually need to make.

You'll be utilizing the Five Types of Confidence, areas based upon the things you have learned so far in this book, specifically those hinged on the sections pertaining to Maslow's hierarchy and the Facets of Fulfillment to observe yourself and reflect.

As you work through this Seven-Day Reset, you'll become more aware of how confident and fulfilled you

are in this current season of your life. Additionally, gaps and opportunities will be exposed for you to choose to do things better, differently, or not at all.

Once you have dedicated your window for your Seven-Day Reset and you've reviewed the definitions for the different kinds of confidence, dedicate some space in your journal. As I mentioned earlier, your only job is to live your life as usual and nonjudgmentally observe yourself. Then, in as much detail as possible, reflect on the week by using the prompts below. Feel free to reflect each evening, or at the end of the week, whichever works for you.

Time Confidence Review

When it comes to my Time Confidence, where did I win today/this week?
Why did it feel like a win?
Can I repeat it?

When it comes to my Time Confidence, where did I struggle?
Was the struggle a result of something I can control?
What caused it?

Was I on time for all of my appointments?
Did I get enough sleep?
Did I sleep in/stay up late, causing deviation from my ideal schedule?

Did I fall prey to distractions?
What were they? Were they worth it?

Did I plan accordingly for the day/week?
Is there something I can do today that my future self will thank me for?
Is there something I could subcontract out so that I can buy back some of my time?
Is there someone I could ask for help to get something done faster?

What is something I could immediately do better to help with my Time Confidence?
What plan could I put in place to help me in the long term?

If you were to rate yourself on a scale of 1 to 10 (1 being the lowest amount of confidence, 10 being the most), how would you rate your Time Confidence for the day/week? And why?

Financial Confidence Review

When it comes to my Financial Confidence, where did I win today/this week?
Why did it feel like a win?
Can I repeat it?

When it comes to my Financial Confidence, where did I struggle?
Was the struggle a result of something I can control? What caused it?

Was I aware of my spending this week?
Did I save what I wanted to?
Did I indulge where I shouldn't have?

Am I able to automate any important payments so I'm not worried about paying them on time?
Do I have any recurring subscriptions or payments that I should probably cancel?
Is there something I could prepare at home that will save me time and money, instead of buying while on the road or ordering out?

Have my spending habits today/this week reflected the goals I have for my Financial Confidence?
How do I feel about my spending today/this week?
How do I feel about my earnings today/this week?

Is there another way I could be earning money?
Are there steps I could be taking to create a plan for that idea?

What could I do differently immediately when it comes to my Financial Confidence?

If you were to rate yourself on a scale of 1 to 10 (1 being the lowest amount of confidence, 10 being the most), how would you rate your Financial Confidence for the day/week? And why?

Commitment Confidence Review

When it comes to my Commitment Confidence, where did I win today/this week?
Why did it feel like a win?
Can I repeat it?

When it comes to my Commitment Confidence, where did I struggle?
Was the struggle a result of something I can control?
What caused it?

Did I do everything I said I would do today/this week?
Why or why not?
How does this make me feel?

Did I say yes to anything that I actually didn't want to do?
Why?
What am I feeling now as a result of this?

Did I say no to the things I didn't want to do?
What am I feeling now as a result of this?

Am I forecasting my fulfillment by committing time on my calendar for the things that are important to me?
Is there something that came up today/this week that I need to add or remove from my calendar?

Do I feel like I am currently overcommitted to obligations? Is there something I can adjust?

Is any other commitment overshadowing the commitment that I've made to myself?
Am I okay with that?

If you were to rate yourself on a scale of 1 to 10 (1 being the lowest amount of confidence, 10 being the most), how would you rate your Commitment Confidence for the day/week? And why?

Decision Confidence Review

When it comes to my Decision Confidence, where did I win today/this week?
Why did it feel like a win?
Can I repeat it?

When it comes to my Decision Confidence, where did I struggle?
Was the struggle a result of something I can control? What caused it?

Am I aware of the decisions I made personally, versus the ones I was roped into today/this week?

Did I redeem my time on things I decided I would do? Or did I spend my time doing things I felt obligated to do?

Would I have chosen to do something differently today/this week?
What and why?

Did I feel guilted, shamed, or coerced into doing something today/this week?
What and why?
Could I have responded differently?
What alternative outcome could have transpired?

Did I decide to have a good day today/this week? Or did I get swept away?
Did I decide to redeem my time instead of spending it?
Did I make any decisions today/this week that empowered me?
If so, what were they?
Did I make any decision today/this week that drained my energy?
If so, what were they?

What is something I can do immediately to increase my Decision Confidence?

If you were to rate yourself on a scale of 1 to 10 (1 being the lowest amount of confidence, 10 being the most), how would you rate your Decision Confidence for the day/week? And why?

Self-Confidence Review

When it comes to my Self-Confidence, where did I win today/this week?
Why did it feel like a win?
Can I repeat it?

When it comes to my Self-Confidence, where did I struggle?
Was the struggle a result of something I can control?
What caused it?

Did I feel mentally and emotionally strong today/this week?
Did I trust myself or doubt myself?
Why?

Did I allocate time to participate in something I know increases my Self-Confidence?
Why or why not? If so, what was it?
Did I feel good in my body?
Why or why not?

Did I feel like my actions were in alignment with my character?
Why or why not?
Did I prioritize my integrity?
How or how not?

Did I need reassurance today/this week? Pertaining to what? Who did I reach out to and why?
What is something I could do immediately that would help me to increase my Self-Confidence?

If you were to rate yourself on a scale of 1 to 10 (1 being the lowest amount of confidence, 10 being the most), how would you rate your Self-Confidence for the day/week? And why?

Takeaways from Your Seven-Day Reset

Once your Seven-Day Reset is complete, you should be clearer about where you are and where you would like to go. If you're completing a Seven-Day Reset for the first time, it is the starting point for change.

I recommend doing a Seven-Day Reset every few months so that you can then Review and Reset. Remember, this is a pursuit, one where we accept and anticipate that we will change and life will happen. So, conducting a Seven-Day Reset several times a year is the least we can do to ensure we are doing what it takes to keep our confidence and remain fulfilled.

After each Seven-Day Reset, take a moment to jot down your five to ten most significant takeaways. They could look something like this:

1. I'm spending way too much time thinking about what to do and when to do it, and because of that, I'm wasting time.
2. I stayed up too late most nights.
3. I need to organize my bills so that I'm not constantly stressing about when things are due.
4. I didn't see or talk to my family enough.
5. I only wrote in my journal two days out of the week.

Once you have clarity around your takeaways, you'll then have the ability to complete a Curated Calendar, which is the intentionally redesigned version of your life, starting with the big picture and working down to the tasks you line up for yourself each day.

COMPLETING YOUR CURATED CALENDAR

To begin, zoom out and take a look at the bigger picture. Remember, we are not trying to cram all of your favorite things into one day and call it your best day. That kind of behavior leads to overwhelm, decision fatigue, and becoming paralyzed when it comes to taking action.

What we *are* doing, instead, is becoming more strategic and process-oriented. We are creating some

standardization in your life. In doing so, you'll be able to create rhythms and routines that will provide the peace *and progress* you're searching for. You'll be able to finally live the life that you've been wanting to and balance all of the most important things, while still enjoying them.

Your Best Day, Every Day

Your Best Day, Every Day is the kind of day you will live from the lens of your Surplus Self. Included in Your Best Day, Every Day are the things that make you feel like you. To design this, you'll refer back to your Time Inventory and take into consideration what you enjoy, don't enjoy, and what is otherwise productive or moves the needle in your life and business.

A great way to do this is to write the time that you want to wake up in the morning at the top of your page and the time you'd like to ideally go to sleep at the bottom of the page. Then, break your day (and page in your journal) into three parts: morning, daytime, and evening.

Using everything you've rediscovered about yourself, what do you now realize are requirements for your average morning, day, and evening? Be as specific as you'd like and remember to create different templates for yourself based on what season of your life you're in and taking into consideration that some days operate differently than others (weekends versus weekdays, gym days versus off days, days you work from home versus in the office, summer versus school year).

Also, be sure to keep all of the tried-and-true tools in mind. Simplify. Fire for effect. Identify the pots that you have on your stove. Who you're leaving the light on for and when you're slamming the door shut.

Realize that this may take some time to settle into. The focus here is to design your best day—not your most productive day or most jam-packed day. Your best day is most likely simple and includes the things you discovered about yourself in Part Two, things that anchor you into who you are so that you experience radical aliveness and fulfillment.

Another way to look at this is that you are outlining the requirements necessary each day for you to feel and be the most YOU that you can be right now. These are nonnegotiable requirements that you have specifically decided on promising to yourself each and every day. You know that if too many days go by without them, you'll end up somewhere you don't want to be and will need another reset.

For example:

WEEKDAY

Morning: Pact Prayer, worship music, at least 15 minutes of quiet time, protein shake.
Day: Move slowly, good music, gym, phone on custom focus mode, clear goals for each day.
Evening: Essential oils, silk PJs, sleep playlist, bed by 9:30 p.m.

WEEKEND

Morning: Sleep in, coffee from favorite cafe, Pact Prayer, church on Sunday.
Day: Laundry, staying home as much as possible, music in the house, windows open.
Evening: TV binge permitted, sleep by 11:00 p.m., favorite dessert.

Micro and Macro Focus Points

Now, realistically, you have things that you're focusing on that could be considered a recurring focus, or something that will take some time to complete. Having a plan for each day and for your next few weeks (or few months) is something helpful to do that will help you to stay focused and excited.

Unlike Your Best Day, Every Day Requirements (which will remain the same, until you decide to change them), your Micro and Macro Focus Points are expected to be different. You will intentionally declare your Micro and Macro Focus Points based on the time frame that works for you.

For years, I have personally been creating Micro To-Do Lists for myself each day. Essentially, a Micro To-Do List includes the top three to five tasks I need to complete each day in addition to the things I have promised myself I would do as requirements for my Best Day, Every Day. I infamously jot these down on a Post-it Note if I'm working from home or at the office, or I add them to my digital calendar if I'm on the road.

You can consider these the "high priority pots" for the day, the pots you want to ensure are taken care of and moved either off the stove altogether or to the back burner after being tended to. Most often, these Micro To-Do List items also have deadlines, and it is imperative that the rest of my day work around them.

If you live a life like mine, though, it can be difficult to achieve even these three to five things. Children get sick, curve balls get thrown, you have to fight through feeling unmotivated. Additionally, if you don't do it today, you may not have the opportunity to get to it for another week or two (location, time, and priorities pending). The Micro To-Do List is small but mighty. These are the things that need to be done, that will get done, period.

Examples of Micro To-Do Lists would be:

- **DAY 1:** Gym, ship all packages, complete laundry, pick kids up early from school for doctor's appointment.
- **DAY 2:** Gym, put together end of month dashboard for work, complete expenses, return important phone calls, visit Dad.
- **DAY 3:** Gym, send invoices, pick up groceries, keep up with inbox, go to post office.
- **DAY 4:** Massage, journal, coffee with Caitlin (PS This day is just as necessary as a day full of "work"), pack suitcase and put in car.
- **DAY 5:** Attend event, catch flight.

Next are the Macro To-Do Lists. The Macro Focus is larger, more project-oriented, and made up of multiple tasks. Typically, I sweep my Macro Focus over the course of a four-month period, but you can choose a time frame that works best for you.

Examples of a Macro To-Do List would be:

- ▶ **FOCUS 1:** Work going to the gym into my life.
- ▶ **FOCUS 2:** Plan birthday party.
- ▶ **FOCUS 3:** Prepare for Christmas.
- ▶ **FOCUS 4:** Save $5000 by end of year.
- ▶ **FOCUS 5:** Set up auto-pay for all of my recurring bills.

Typically, my Macro To-Do List has several points of focus, each with their own list of tasks that need to be completed. This is where I am intentionally and strategically multitasking, with broad brush strokes, over the course of several months, to complete what I had set out to accomplish.

For example, Focus 1 is a process goal that involves incorporating a new long-term behavior into my life by starting with baby steps. As I mentioned earlier in the book, there were years of my life when I never saw the inside of the gym. I knew better than to think I was going to suddenly want to be there every day.

Instead, I hired a trainer and focused on getting to the gym two days a week, with the intent to increase that expectation as I got more confident. Today, I'm in the gym

five days a week, usually, and if I take time off, I do so confidently, knowing it is for a good reason.

Focus 2 and 3 are more recurring outcome-based goals, where there is an end in sight. I could choose to wait until the last minute, scurry to throw something together, and most likely hate myself later for it, or I could prepare in advance and be mindful of the details around the birthday party and Christmas. Focus 4 is an outcome-based goal but requires some process changes. To save the money by a particular date, I'll have to adjust in other areas of my life and habitually set the money aside, preferably in a way that is automated.

Which brings me to Focus 5, which again, is an outcome-based goal, meaning, we know what we are setting out to do, but requires a process focus, one that takes into consideration that these payments will be recurring and will affect me even after the auto-pay is set up.

Feeling rushed and unsure, not getting the results we need or want, or thinking we're going to overhaul our lives and suddenly be someone we are not is not the way to approach making sustainable changes.

FYI, we are no longer the people who voluntarily make ourselves available for that. There is enough chaos in life to navigate as it is. If there are things that are within our control to predict and plan for, that is exactly what we will do. If there are steps that can be taken to slowly chip away at a project and map out a timeline that isn't overwhelming, we are going to do that. If we say we are going to do something, we are going to do it, all while confidently protecting the components of having our Best Day, Every Day.

Pulling It Together

In the same way that we pay our utility bills, schedule tire rotations and oil changes for our vehicles, or plug in our phones to charge each night before going to bed, establishing a process for our own personal preventive maintenance is key to creating confidence and finding fulfillment.

What would happen if we never charged our phones and expected them to still function? If we never paid our electric bills and expected the lights to turn on? If we never tended to the maintenance of our vehicles?

Creating your Curated Calendar *is* redefining your life. It is the conduit for redeeming your time in a new way and implementing joy (in all the ways *you* define it). It is also the tool that will allow you to perpetually redefine your life, to adjust and evolve as often as you do.

Everything you have learned and processed up to this point has been valuable, but don't forget that it doesn't mean much at all if you don't actually implement it. The only thing worse than taking a chance at implementing it the wrong way is choosing to do nothing at all with all of the work you've done throughout the reading of this book.

Be mindful, though, of winding up back at square one with a revised version of a full life, one where you're exerting energy in the wrong places. Just because your day is full does not mean you're fulfilled. Running in circles will burn calories, but it won't get you anywhere.

To quote the late American engineer, author, and philosopher Alfred Montapert, "Do not confuse motion

and progress. A *rocking horse* keeps moving but does not make any progress."[16]

It can be exciting to pick up a new book, learn new information, and let your mind wander with all of the possibilities. It can be equally exciting to plan ways to implement these ideas, buy new things to support those ideas, and talk to your friends about all the ways your life is going to change.

Doing the thing, the actual thing, you were excited to do, is totally different.

Do not lose sight of this journey. It's not about more. It's not about hustle. It's not about stress.

It's about rediscovering yourself, identifying *your* needs, firing for effect to satisfy them, and redefining your life to suit. It's about intimately getting to know yourself, the person God intended you to be. Tending to the child within you, the hurt and wounded parts inside.

It's about loving and accepting who you are and what you've been through, while also embracing the newness of who you're becoming.

It's about realizing that, by default, you have an advantage and are perfectly equipped and positioned to make your next move.

Think about work. If something is important at work, do you miss it? If people are depending on you to perform, do you show up? It's remarkable how many of us know what it is like to clock in and out on time because we "have" to, at jobs we don't even like, but do not prioritize our own needs and joy with the same kind of conviction.

If you're a parent, it is just as relatable. I see parents never miss a ball game, dance class, or fundraiser. They're frantically running from here to there, coffee in hand, lacking sleep and energy, wishing the days were over instead of enjoying the moments. Wishing they somehow were able to create time and space for their work, spouse, and children, yet unable to justify doing something for themselves.

Not anymore.

This is where we show up for ourselves the way we do for everyone else. This is the era where we finally connect the dots and understand that when we pursue the person God has intended us to be, when we prioritize getting to know who we actually are, we are able to expand and explore life in ways we never thought imaginable.

It is in this place that we can serve the people we love the most. Where we can allow others into our lives who want to truly support us and see us win. Where we can show up to each activity, calm and present. Where we can excel in our careers and invest in our continuing education. Where we can have the best relationships, be vulnerable, emotional, and real. Where we can have our Best Day, Every Day, and confidently balance all the most important things in life *and* still enjoy them.

Back in the Bathtub

I was physically exhausted from a long week of sick children, chaos at work, a phone that didn't stop ringing,

a car that never stopped moving, and an endless list of all the things that everyone needed from me.

What time was it anyway?

All I know is when I got into the tub, it was daylight, and now it wasn't.

I cried.

Four years removed from where all of this first began, and there I was, back in the bathtub.

I tried to rationalize what was happening, but then I just decided to let myself have it. Instead of considering myself foolish for feeling these feelings and having this internal battle, I decided to let myself have the time and space I needed to process what I needed to. To explore and experience, to be emotional and extra, to let myself derail, without resisting.

The pressure and overwhelm of all of the responsibilities around me made me feel like I was being forced to crawl through a space—a space I obviously couldn't fit in, that I wasn't built for. It was like I was being asked to fly or perform a miracle.

This was hard. This day was hard.

When I felt like I had had enough, I sat up and let the bath begin to drain. I stood up and grabbed a towel from the shelf, patted myself dry, and tucked myself into my white waffle robe.

I looked in the mirror and took a deep breath, wiping the tears from my eyes, putting an end to my moment.

Because of the work I have done, the time I have put in, and the pact I have made to myself…

Because I have already explored my limitations and struggles ...

Because I was able to give myself a runway to hit the ground running ...

... I was able to get out of the bathtub in forty-five minutes instead of four hours.

... I was able to get on a call with my coach and talk it out.

... I was able to make myself a cup of tea and sit with my journal.

... I was able to allow myself to be a victim for moments instead of months.

... I was able to identify the pressure and the discomfort so that I could lean into it and leverage it.

... I was able to give myself the things I needed, step back into my confidence, and find joy in the fulfillment of saying yes to myself.

... I was able to understand that this was temporary. That having a moment was necessary. And that there was no need or reason for me to judge myself.

... I was able to lean on my tools and awareness.

... I was able to see that this was not the end.

I could leverage all of the things I had experienced, realizing that I now have exponentially more than I did just four years ago.

More resources.

More people.

More faith.

More trust.

More resilience.
More confidence.
More fulfillment.
More excitement for the future.

God never promised it would be easy, but it is worth it, and there is more. How freeing is it to now know that you do not have to strive for some unrealistic version of perfection in order to live and enjoy a happy, healthy, and beautiful life? Instead, you need only to pursue the person God has intended you to be, to risk being seen in all of your glory, to reassemble yourself, without the wax.

ACKNOWLEDGMENTS

Writing this book so effortlessly has been a result of years and years of reflection. Years spent self-isolating, self-reflecting, analyzing how and why life happens the way it does. To be honest, I have felt utterly alone more times than not over the past ten years. Alone in my relationships, alone in my motherhood, in my choices, and in my growth.

I can see now how untrue that is, that while my time spent alone has been pivotal, there have been those in my life who have played their parts. Some for a short term. Some who will unconditionally love me and my children forever.

To begin, I have to give credit where credit is due. The artist and provider behind this life I get to live, this masterpiece of beauty, love, and majesty is God. I am grateful to know His steadfast presence, abundant provision, and perfect timing.

Next, my Village family. Establishing The Village has been an experience that changed me on a molecular level. It was even more impactful when I had the opportunity to open the doors to The Village 15401 with Kate Kimm. To Kate, thank you for seeing the same vision and partnering with me to bring it to life. To all of you who have attended a Village Meeting or retreat, who have ever given me the

honor of trusting me with your story and being a part of your journey, thank you. I see you, and I love you. Keep going.

To those I mention in this book, some of you teachers, some mentors, some friends...you have been a part of my life and my story. The impact you have made on me has made its way here, where it will now reach others. I am eternally grateful that God placed you in my life when I needed you most. Thank you.

To Sonya and Tommy Dallas, along with the Bible Baptist family in Brownsville, PA., thank you for being my firm foundation from which to rebuild. You really have no idea how much your faith, friendship, and prayers supported me through times that felt completely unmanageable. Tommy, hearing you teach God's Word and seeing the church expand with your leadership has been inspiring. Sonya, having you as a friend has helped me to be a better friend to others. Thank you for welcoming me to the church and accepting me. Thank you for praying the most important prayer I'll ever pray with me in the old church basement on July 6, 2020. The two of you are admirable examples of consistency, resilience, and obedience. Don't think for a second that it goes unnoticed. Without a doubt, you are impacting souls.

Heather, your ongoing support through the years has meant so much to me. I adore our friendship and your willingness to help me get this message out into the world. I am so proud of how much you have committed to yourself, your business, and those around you. It goes without saying that your design expertise (featured on the

cover) is remarkable and when it comes to design, nobody does it like you. Thank you.

Robin, the way you have always believed in me (and those around you) is admirable. You are an incredible mother and the most kind person I have ever met. Thanks to you, I have photos and experiences that highlight some of the most transformative moments in my life and my business…all of those moments brought me here. Your willingness to support my dreams has meant so much to me. Thank you for always being there.

Gianna, I prayed for you for years. You have no idea how much weight you take off of my shoulders, how much your assistance means to me, how much further I have been able to progress my endeavors because of you. Thank you for your generosity, your kind heart, and your spirit. Thank you for reminding me to slow down, to lean on God, and to focus on the things that matter most (like getting enough protein). This is just the beginning.

Loren, your ability to support your friends and family is a gift. Thank you for standing by me through all of these changes and showing me what it looks like to have unconditional support. I'm so grateful that we have been able to stay close and balance life and a friendship that urges each of us to continue to grow while accepting our humanness. You shine divine joy in every room you enter; don't forget that. If you do, I'll have plenty of time to remind you during our seven-hour brunch at Nino's.

Nicole, (G). You. You were the first person to sign up for my first retreat many moons ago. You were the first person to be at my side during my divorce. You are strong, you

are real, and you are enough. I cherish our friendship and your support more than you know. Because of you, I've embraced the chaos and manage the lids on my pots with strength and elegance. Because of you, I embrace adulting and get the hard things done. Because of you, I do not let my past define me. I'm so grateful for you. I love you.

Caitlin, we sure have been on quite the ride together. God only knows what life would look like had we not met years ago. Thank you for our regular chats and for reminding me to continue to chase the woman God has intended me to be, to be vigilant when it comes to the lies of this world, to be aware of all of God's promises, and to mount up with wings like eagles. (Oh, and for capturing the incredible photos that are featured on the cover.)

Kaitlen, it would be silly for me to break up with you now. You know too much, and so do your parents. I truly do not know what I did to deserve a friend like you, and I definitely do not voice my love and appreciation for you enough. Not many people get to experience a friendship that is as long as ours, and I'm so grateful that we can. Thank you for being the Baby Spice to my Sporty Spice, for having pizza & milkshakes at my dad's, for taking me to my first concert (#HANSON4LYF), for coming to my apartment when my boyfriend broke up with me in college, for always being by my side, and for being an example to our daughters. Our friendship is my favorite love story.

Mom & Joe, thank you for being an example of working hard and playing hard, of showing the results of continued effort, and the importance of always having the next

project and the next vacation planned. I love you both and am grateful that Arlyn and Eva get to have a Bibi and Pappy Joe.

Jes, you'll always be my little sis. ILY

Dad, I'll always be your little girl. I love you.

Bill, Faith, Jesse, Akemi, Britt, Josiah, and the rest of The StoryBuilders Team, your promise was that you'd assist me in creating a book I was proud of. That's what has made all the difference. Each one of you is unique, creative, and most of all, invested. Since our very first team call, I sensed a passion for this project from each one of you, one that confirmed that this book was needed and that its contents are significant. I could not have done this without your hard work, careful planning, and accountability. Now, my hope is to make you proud, as a part of The StoryBuilders Press family.

Jen Truitt, thank you for loving this book as much as I do. Your influence and essence are sprinkled like magic fairy dust throughout these pages and without you, it wouldn't be the same. I'm grateful for our weekly calls, your editing expertise, our brainstorming sessions, and most of all, your patience. Thank you for letting me break the rules of writing, for supporting my Grey's Anatomy reference in Chapter Seven, for deleting the recordings from our meetings that were more like therapy sessions, and for making this process feel effortless.

To the Wild Horse Recording Team, it is because of you that the people who need this book will have the

opportunity to listen to it. I appreciate all of the support during the recording process and your creative genius in the post-production. Thank you for bringing this book to life!

To Lewis Howes, Jamie Arrington, and The Greatness Team, without your endless drive and dedication to live out your Meaningful Mission, I would not be here. Period. Because of your podcast and most recent book, I had the opportunity to attend an event where I was introduced to Bill, providing a connection that would help me to turn something I had only dreamed about into reality. You reminded me to connect with and talk to everyone, that everyone has a story, that everyone matters. You reminded me to be curious, to ask questions, to listen. For these things, I am most grateful. Thank you.

ENDNOTES

1. Neumann, Kimberly Dawn. "Liminal Space: What Is It and How Does It Affect Your Mental Health?" Forbes, April 26, 2023. https://www.forbes.com/health/mind/what-is-liminal-space/

2. Carrey, Jim. "The Prison of Becoming." Signature Gallery Group. Accessed June 13, 2024. https://www.signature-galleries.com/artwork/prison-of-becoming

3. Furtick, Steven. "This Is That Day | Pastor Steven Furtick | Elevation Church." YouTube, January 7, 2024. https://www.youtube.com/watch?v=FbL65RNnPbk.

4. Berg, Sara. "What Doctors Wish Patients Knew about Decision Fatigue." American Medical Association, November 19, 2021. https://www.ama-assn.org/delivering-care/public-health/what-doctors-wish-patients-knew-about-decision-fatigue

5. Maslow, Abraham. Toward a Psychology of Being. Sublime Books, 2014, 87.

6. Ibid

7. Maslow, Abraham, Deborah C. Stephens, and Gary Heil. Management. New York: John Wiley & Sons, Inc., 1998, 3.

8. Maslow, Abraham, Deborah C. Stephens, and Gary Heil. Management. New York: John Wiley & Sons, Inc., 1998, xii.

9. Furtick, Steven. "This Is That Day | Pastor Steven Furtick | Elevation Church." YouTube, January 7, 2024. https://www.youtube.com/watch?v=FbL65RNnPbk

10 Furtick, Steven. "Focus on Today | Steven Furtick." YouTube, January 23, 2024. https://www.youtube.com/watch?v=7749z-aq0XU

11 Furtick, Steven. "You Have to Move Forward: Steven Furtick." YouTube, December 31, 2019. https://youtu.be/w56SX5xu1Ok?si=LmfiVvsf_-0RFYPz

12 "What's So Special About Your Fingerprints?" Wonderopolis. Accessed June 13, 2024. https://www.wonderopolis.org/wonder/what-s-so-special-about-your-fingerprints/

13 Furtick, Steven. "Drained?: If You're Feeling Drained, It May Be Time to Check Where You're Putting Your Energy.: By Steven Furtick." Facebook, May 14, 2019. https://www.facebook.com/StevenFurtick/videos/1976235742488207/

14 Ibid

15 Haggai 1:5-7. English Standard Version

16 "A Quote by Alfred A. Montapert." Goodreads. Accessed June 13, 2024. https://www.goodreads.com/quotes/165647-do-not-confuse-motion-and-progress-a-rocking-horse-keep

ABOUT THE AUTHOR

Rebecca Corvin is an author, podcast host, personal development coach, and devoted mother who is passionate about normalizing conversations around often unspoken yet universally experienced challenges. Since 2015, she has been guiding individuals through balancing life's demands and navigating major life changes. Drawing from her own personal development journey, her Christian faith, and concepts stemming from the late Abraham Maslow's work, Rebecca offers effective strategies to help others gain the confidence to make long-term, impactful changes.

Rebecca is the creator of The Liminal Advantage™, an innovative approach that leverages life's circumstances to shift perspectives from feeling stuck to recognizing strategic positioning for future growth. For years, she has facilitated her signature Village Meetings and women's retreats, bringing together individuals ready to fully realize their potential and relentlessly pursue their true selves.

In addition to her coaching work, Rebecca has been a professional in the oil and gas industry since 2011, specializing in occupational safety and health. She is

currently working on new book projects and booking speaking and consulting engagements. Rebecca resides in Southwestern Pennsylvania with her two children, Arlyn and Eva.

Printed in the USA
CPSIA information can be obtained
at www.ICGtesting.com
LVHW021604300824
789731LV00001B/112

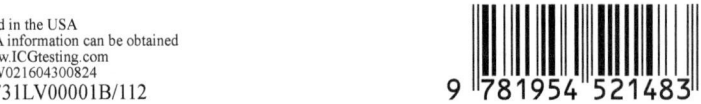